DAILY ZEN
— doodles —

365
TANGLE CREATI
— *for* —
INSPIRATION, RELAXATION
and MINDFULNESS

meera lee patel

Ulysses Press

Published in the U.S. by
Ulysses Press
P.O. Box 3440
Berkeley, CA 94703
www.ulyssespress.com

ISBN: 978-1-61243-359-2
Library of Congress Control Number 2013957240

Printed in Canada by Marquis Book Printing

10 9 8 7 6 5 4

Acquisitions Editor: Keith Riegert
Managing Editor: Claire Chun
Editors: Alice Riegert, Sayre Van Young
Cover design: Meera Lee Patel
Interior design: Jake Flaherty

Distributed by Publishers Group West

For Mom, who lent me her shadow,
and Dad, who always believes.

Introduction

Quieting your mind is a practice; it requires patience, perseverance, and most importantly, time.

The practice of meditation has been around for hundreds of thousands of years. As humans, we are constantly searching for ways to reassure and relax ourselves, to find peace among the confusion and chaos that seeps into our daily lives.

This book is designed to help you take that step towards mindfulness. These zentangle drawings are simple exercises in meditation. Each exercise will guide you through a 15- to 20-minute meditation during which you will complete a drawing. Every page in this book contains a prompt (or starting point) that you'll fill in with repetitive patterns or doodles—wherever your mind takes you.

The images at the beginning of the book are filled in to give you some inspiration on where you can take these drawings. Most of the prompts, however, are very simple, offering absolute doodling freedom. It's important to remember that there is no proper way to complete each drawing; the prompts are merely guides facilitating your creativity and mind's quiet.

Before you begin each exercise, find a quiet place where you can spend the next 20 minutes. Take slow, deep breaths, and focus on the patterns you are creating within each prompt. If you find yourself fixating on the shapes you're creating or the evenness of each line, take a moment to concentrate on that thought; then let it go.

The objective is not to create exact or perfect pattern-work; it is to so fully immerse yourself in the present moment that your mind calms down, your heart beats a bit more gently, and the environment around you dissolves into the ether. Remember, the only truth is where you are in each moment; hold yourself in it, and then let it pass.

A Note from the Author

Being truly present in my everyday life has been a continual challenge for me, and the caveat for developing a daily meditation practice. Through this practice, I've developed mindfulness, a trait that has taught me to calm my inner critic, quiet the insecurities that tug at me, and prioritize the vital parts of my life. With mindfulness comes self-awareness, which can lead to surprising discoveries: some of the darkest and most clandestine places within us are found during meditation. Coming to terms with these truths and learning to row through the rough waters is difficult but necessary, and essentially beautiful.

Cultivating mindfulness through meditation offers the freedom to find happiness anywhere, in any moment. The quotes in this book are ones that resonate with me, that take me out of the past or future (where I often find myself wandering) and bring me back to where I am: here, in the now. I hope they will do the same for you.

The present moment is an infinitesimal speck in an unknown expanse of time: it sparkles and glows, consisting entirely of light, magic, and possibility. It is yours, if you choose to take it (and I hope you do).

Life consists with wildness. The most alive is the wildest.
Not yet subdued to man, its presence refreshes him.

—HENRY DAVID THOREAU

Through learning to listen to our own intuition, it develops to a constantly available inner source of love, truth and wisdom. We can close our eyes, go within, and always receive the right guidance.

—SWAMI DHYAN GITEN

For when a man no longer confuses himself with the definition of himself that others have given him, he is at once universal and unique.

—ALAN WATTS

"Cultivate your own spirit." It means not to go
seeking for something outside of yourself.
—SHUNRYU SUZUKI

The Master observes the world but trusts his inner vision. He allows things to come and go. His heart is open as the sky.

—LAO TZU

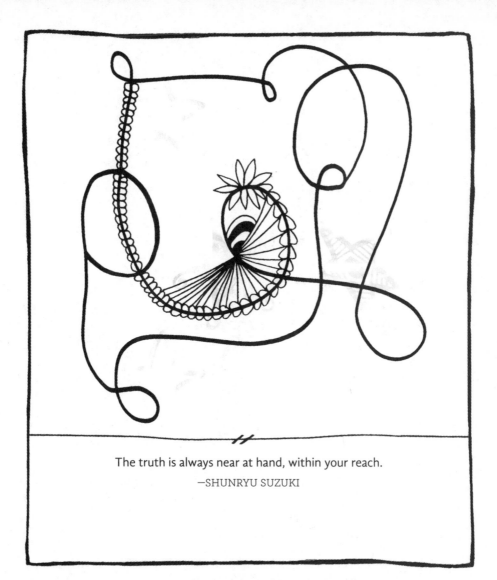

The truth is always near at hand, within your reach.

—SHUNRYU SUZUKI

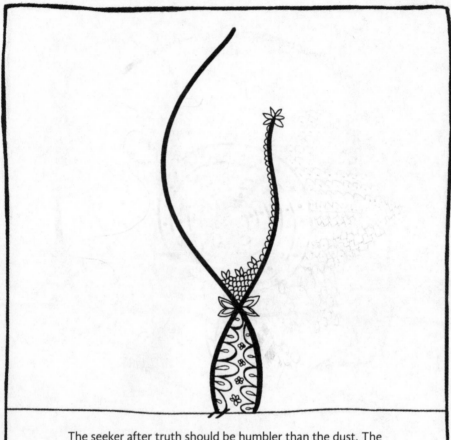

The seeker after truth should be humbler than the dust. The world crushes the dust under its feet, but the seeker after truth should so humble himself that even the dust could crush him. Only then, and not till then, will he have a glimpse of truth.

—MAHATMA GANDHI

It is our own mental attitude which makes the world what it is for us. Our thoughts make things beautiful, our thoughts make things ugly. The whole world is in our own minds.

—SWAMI VIVEKANANDA

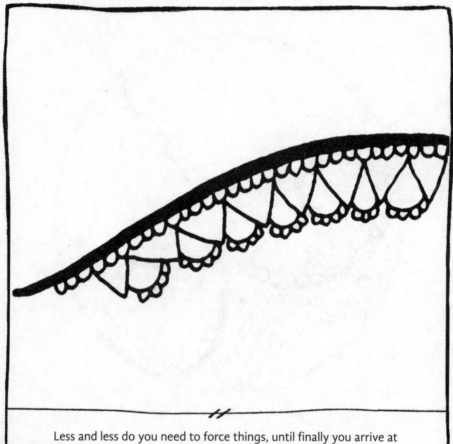

Less and less do you need to force things, until finally you arrive at non-action. When nothing is done, nothing is left undone.

—LAO TZU

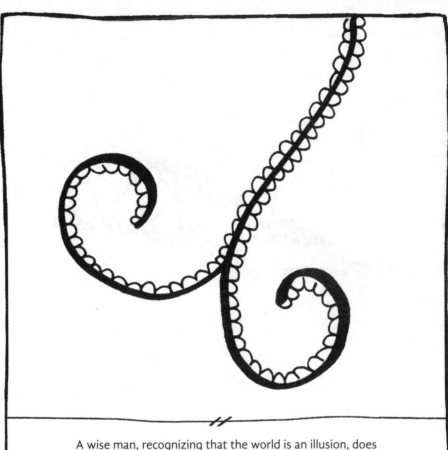

A wise man, recognizing that the world is an illusion, does
not act as if it were real, so he escapes the suffering.

—BUDDHA (as quoted by Bukkyo Dendo Kyokai)

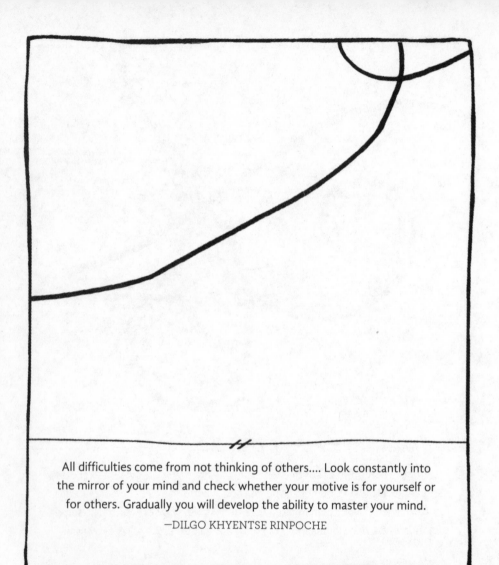

All difficulties come from not thinking of others.... Look constantly into
the mirror of your mind and check whether your motive is for yourself or
for others. Gradually you will develop the ability to master your mind.
—DILGO KHYENTSE RINPOCHE

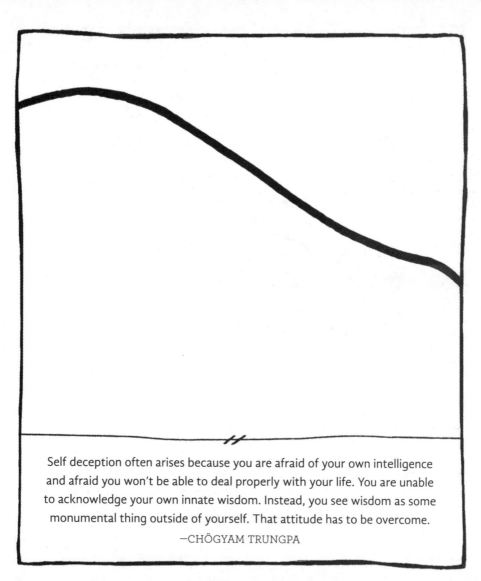

Self deception often arises because you are afraid of your own intelligence and afraid you won't be able to deal properly with your life. You are unable to acknowledge your own innate wisdom. Instead, you see wisdom as some monumental thing outside of yourself. That attitude has to be overcome.

—CHÖGYAM TRUNGPA

As is the sight of the sweetest Honey to the traveler in the Desert, so is the perception of the ever-effulgent.

—HINDU PROVERB

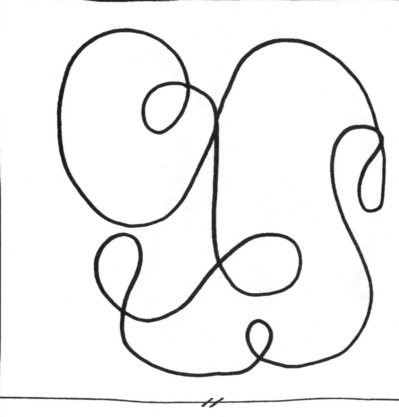

Who ranks as the Highest? One who is not afraid of breaking
attachment, who has cast out anger and desire, and lifted
the barrier which prevented any forward movement.

—BUDDHA

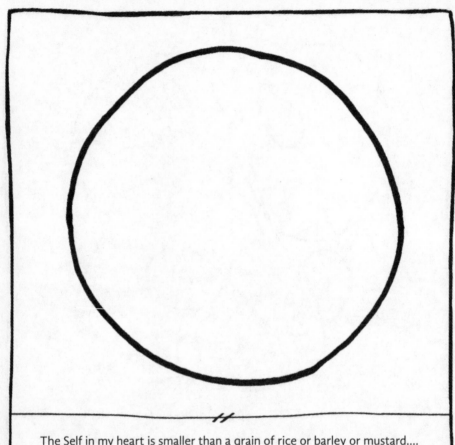

The Self in my heart is smaller than a grain of rice or barley or mustard....
And yet, this Self in my heart is bigger than the earth, more extensive,
than the atmosphere, wider than the sky, greater than all these worlds
together. It is all action, all desire, all smell, all taste; It pervades all that is.

—HINDU PROVERB

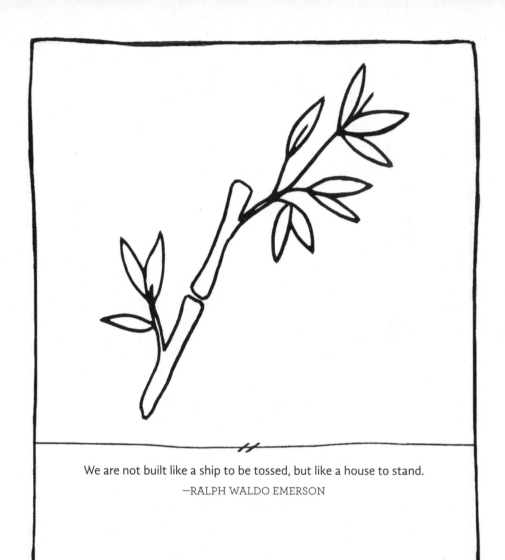

We are not built like a ship to be tossed, but like a house to stand.

—RALPH WALDO EMERSON

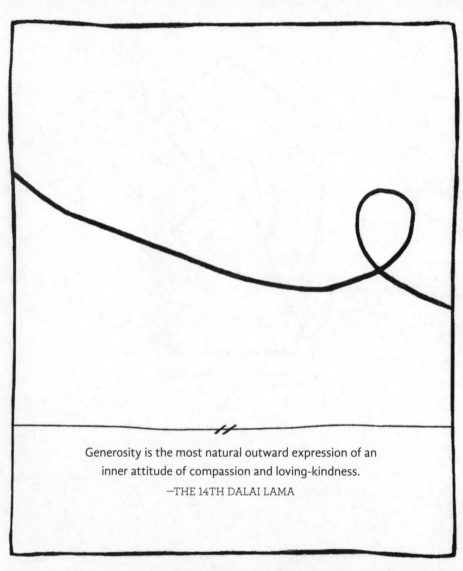

Generosity is the most natural outward expression of an
inner attitude of compassion and loving-kindness.

—THE 14TH DALAI LAMA

The mantra is of no use when not chanted. The house decays
when it is not repaired. The body deteriorates when it is
not cared for. The guard fails when the eyes close.

—BUDDHA

When our mindfulness touches those we love, they will bloom like flowers.

—THICH NHAT HANH

The power of unfulfilled desires is the root of all of man's slavery.

—PARAMAHANSA YOGANANDA

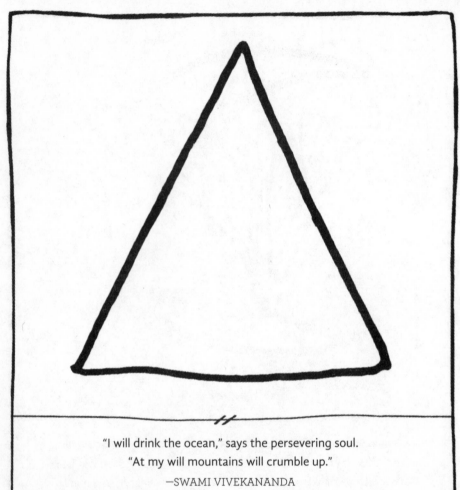

"I will drink the ocean," says the persevering soul.
"At my will mountains will crumble up."
—SWAMI VIVEKANANDA

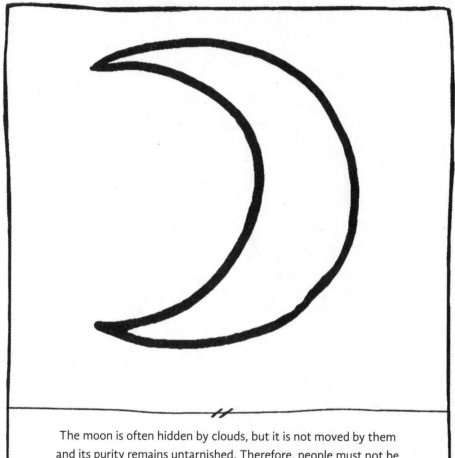

The moon is often hidden by clouds, but it is not moved by them
and its purity remains untarnished. Therefore, people must not be
deluded into thinking that this defiled mind is their own true mind.

—BUDDHA (as quoted by Bukkyo Dendo Kyokai)

One who pressed forward incessantly and never rested from his labors, who grew fast and made infinite demands on life, would always find himself in a new country or wilderness, and surrounded by the raw material of life.

—HENRY DAVID THOREAU

Practice not-doing, and everything will fall into place.

—LAO TZU

The unity of life is an unalterable law, the central law of existence.
We cannot break it; we can only break ourselves against it.

—EKNATH EASWARAN

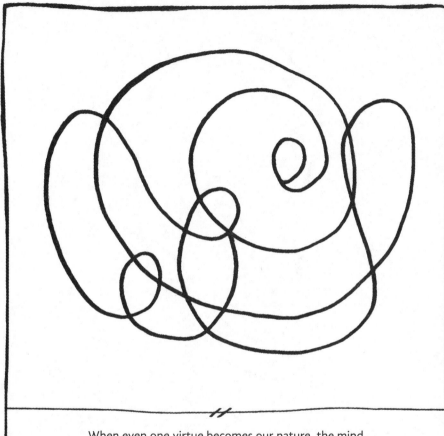

When even one virtue becomes our nature, the mind
becomes clean and tranquil. Then there is no need to practice
meditation; we will automatically be meditating always.

—SWAMI SATCHIDANANDA

That is the Great Real Self who, though without hands or feet, is the swiftest of approach; though without eyes or ears, sees and hears everything; though uncomprehended, comprehends everything knowable.

—HINDU PROVERB

Sun has a sense of all-pervasive brilliance, which does not discriminate in the slightest. It is the goodness that exists in a situation, in oneself, and in one's world, which is expressed without doubt, hesitation, or regret...the Sun principle also includes the notion of blessings descending upon us and creating sacred world.

—CHÖGYAM TRUNGPA

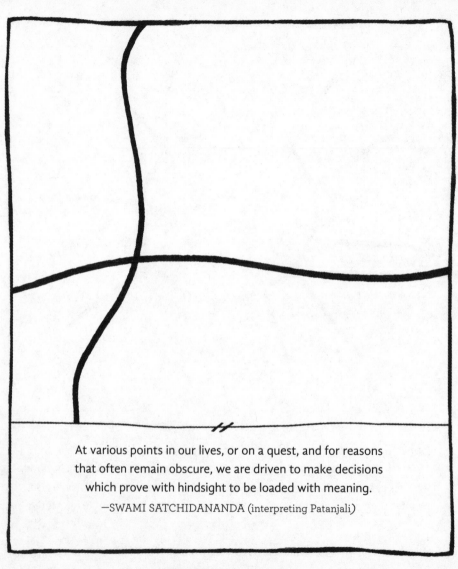

At various points in our lives, or on a quest, and for reasons
that often remain obscure, we are driven to make decisions
which prove with hindsight to be loaded with meaning.

—SWAMI SATCHIDANANDA (interpreting Patanjali)

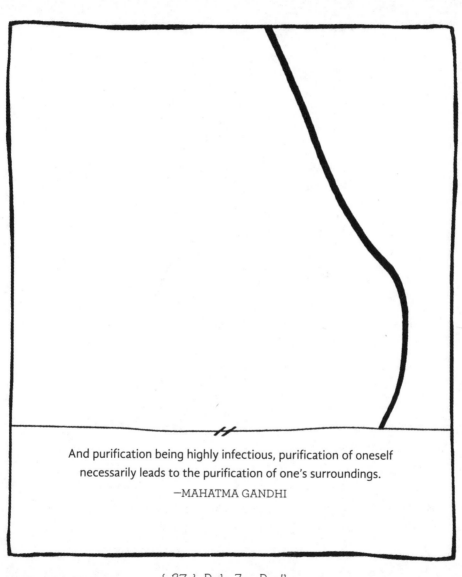

And purification being highly infectious, purification of oneself
necessarily leads to the purification of one's surroundings.
—MAHATMA GANDHI

All this had always been and he had never seen it; he was never present.
Now he was present and belonged to it. Through his eyes he saw light
and shadows; through his mind he was aware of moon and stars.

—HERMANN HESSE

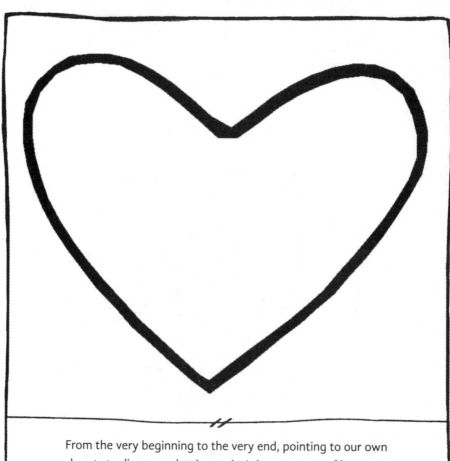

From the very beginning to the very end, pointing to our own hearts to discover what is true isn't just a matter of honesty but also of compassion and respect for what we see.

—PEMA CHÖDRÖN

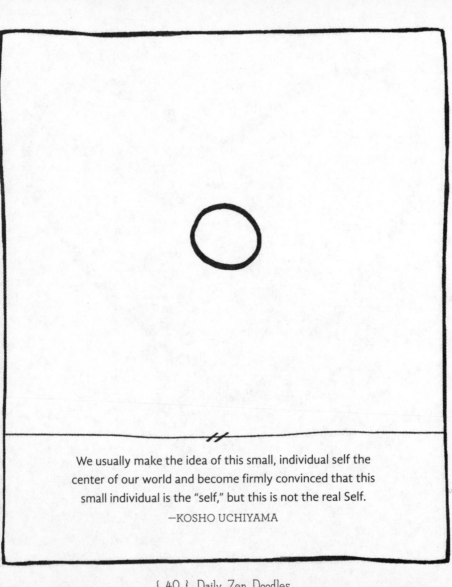

We usually make the idea of this small, individual self the
center of our world and become firmly convinced that this
small individual is the "self," but this is not the real Self.

—KOSHO UCHIYAMA

Don't allow yourself to be too sensitive, constantly stirred up by the emotions and the demands of the body and by external conditions. Try to remain in the inner stillness of the soul. That is where your real home is.

—SRI DAYA MATA

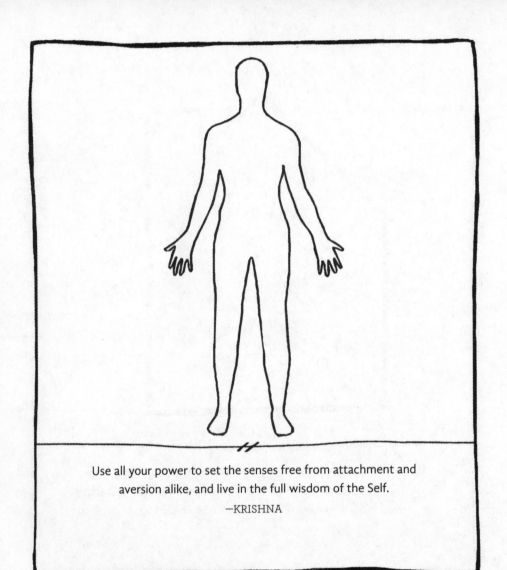

Use all your power to set the senses free from attachment and aversion alike, and live in the full wisdom of the Self.

—KRISHNA

In the therapeutic process based on awareness, there exists no
"I"—it just exists a presence, a light, a love and a silence.
—SWAMI DHYAN GITEN

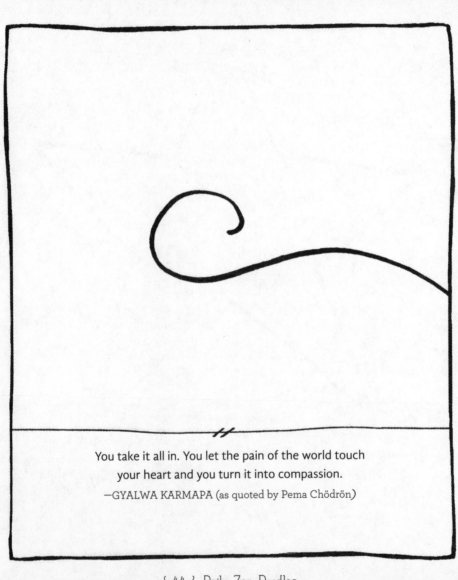

You take it all in. You let the pain of the world touch
your heart and you turn it into compassion.

—GYALWA KARMAPA (as quoted by Pema Chödrön)

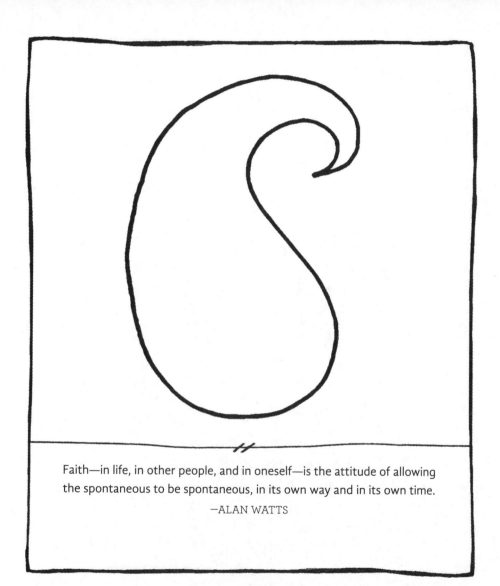

Faith—in life, in other people, and in oneself—is the attitude of allowing the spontaneous to be spontaneous, in its own way and in its own time.

—ALAN WATTS

Within each one of us is a temple of stillness that
permits no intrusion of the world's turmoil.

—SRI DAYA MATA

You must live in the present, launch yourself on every wave, find your eternity in each moment. Fools stand on their island opportunities and look toward another land. There is no other land; there is no other life but this.

—HENRY DAVID THOREAU

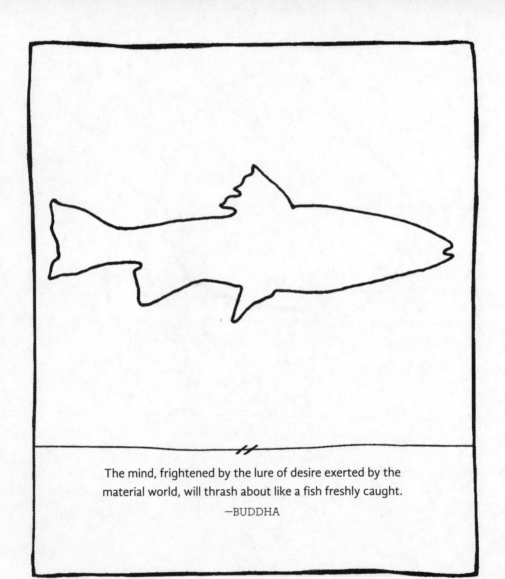

The mind, frightened by the lure of desire exerted by the material world, will thrash about like a fish freshly caught.

—BUDDHA

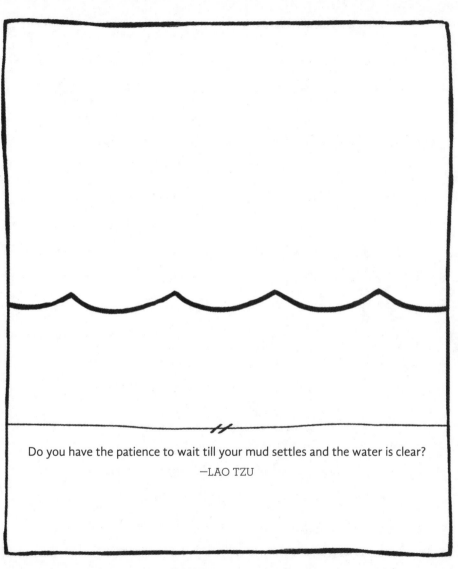

Do you have the patience to wait till your mud settles and the water is clear?

—LAO TZU

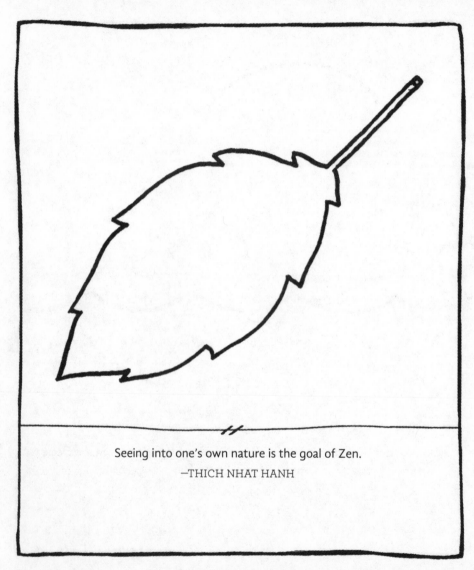

Seeing into one's own nature is the goal of Zen.

—THICH NHAT HANH

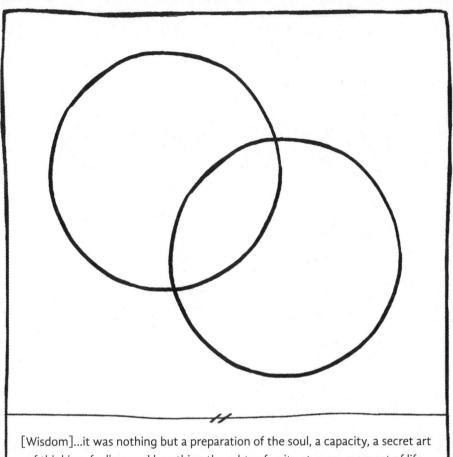

[Wisdom]...it was nothing but a preparation of the soul, a capacity, a secret art of thinking, feeling, and breathing thoughts of unity at every moment of life.

—HERMANN HESSE

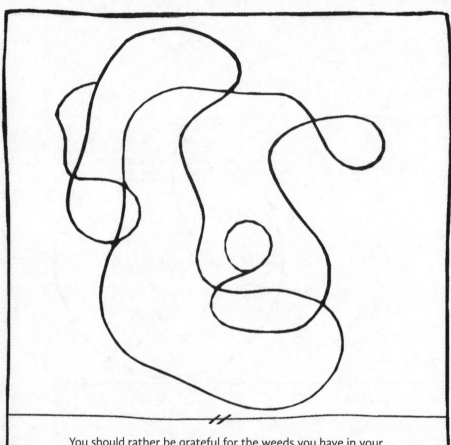

You should rather be grateful for the weeds you have in your
mind, because eventually they will enrich your practice.

—SHUNRYU SUZUKI

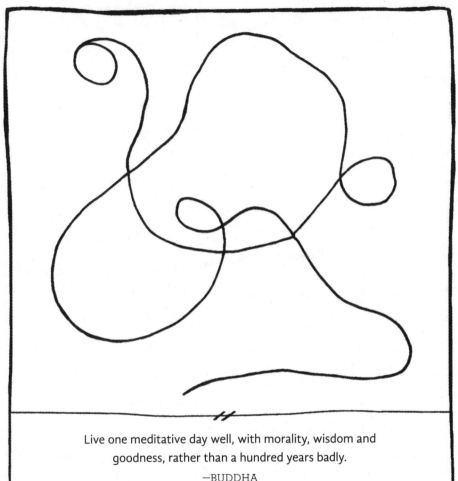

Live one meditative day well, with morality, wisdom and goodness, rather than a hundred years badly.

—BUDDHA

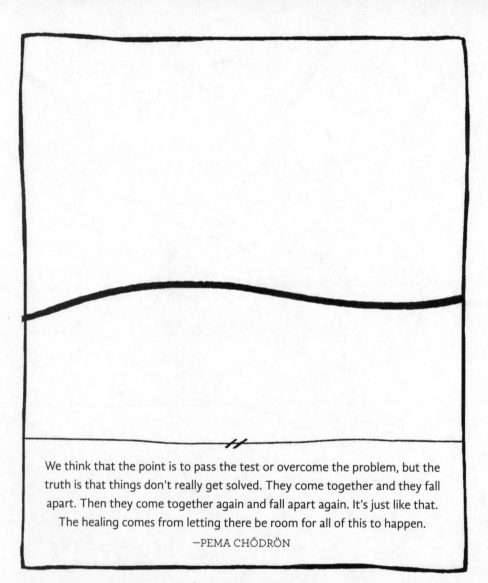

We think that the point is to pass the test or overcome the problem, but the truth is that things don't really get solved. They come together and they fall apart. Then they come together again and fall apart again. It's just like that. The healing comes from letting there be room for all of this to happen.

—PEMA CHÖDRÖN

This experience of grace is not unlikely to come to most of us who are steadfast in their meditation and who...are doing the very best they can.

—EKNATH EASWARAN

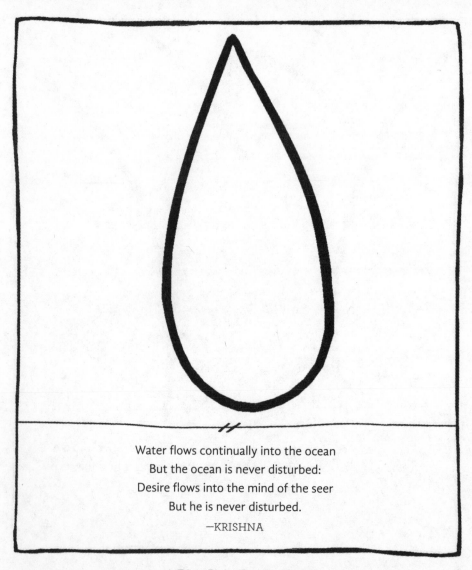

Water flows continually into the ocean
But the ocean is never disturbed:
Desire flows into the mind of the seer
But he is never disturbed.

—KRISHNA

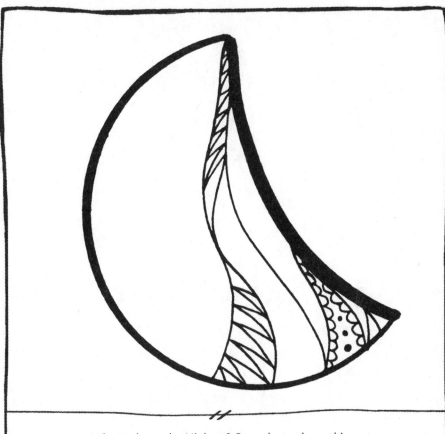

Who ranks as the Highest? One who seeks nothing.
One who is as pure as the full moon.

—BUDDHA

If one knows that everything is impermanent, one does not grasp, and if one does not grasp, one will not think in terms of having or lacking, and therefore one lives fully.

—DZONGSAR KHYENTSE RINPOCHE

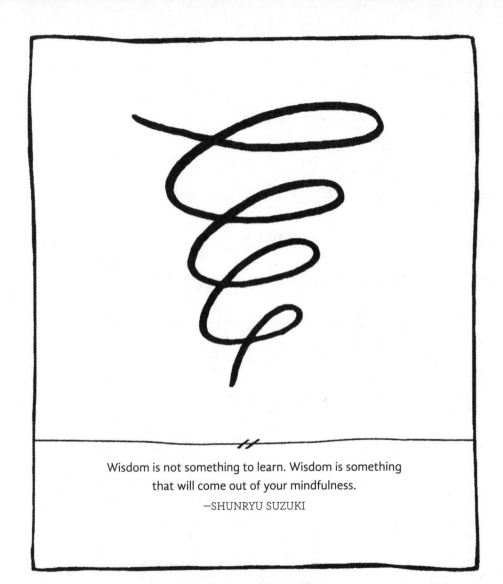

Wisdom is not something to learn. Wisdom is something
that will come out of your mindfulness.
—SHUNRYU SUZUKI

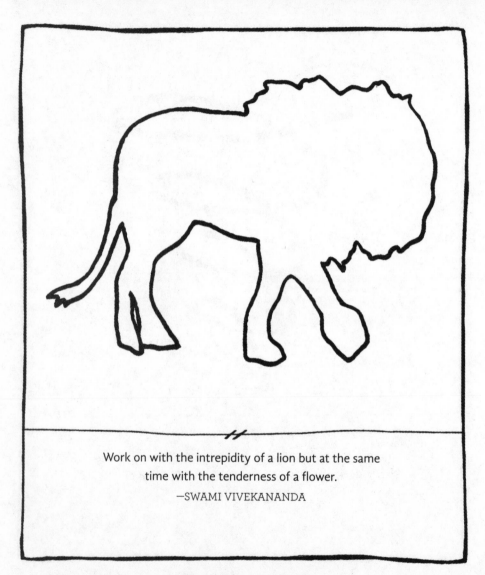

Work on with the intrepidity of a lion but at the same
time with the tenderness of a flower.

—SWAMI VIVEKANANDA

Give up anger and pride and have no attachments. If you do not possess anybody or anything, you will not have to endure suffering.

—BUDDHA

A good traveler has no fixed plans and is not intent on arriving.

—LAO TZU

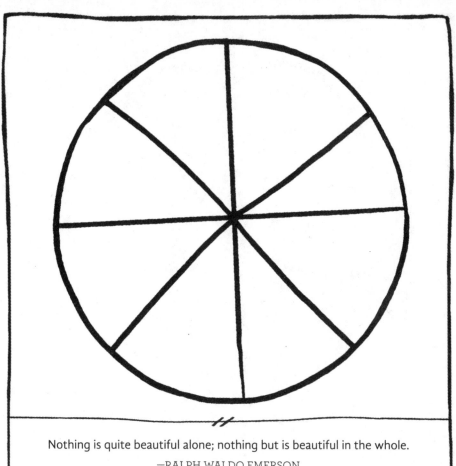

Nothing is quite beautiful alone; nothing but is beautiful in the whole.

—RALPH WALDO EMERSON

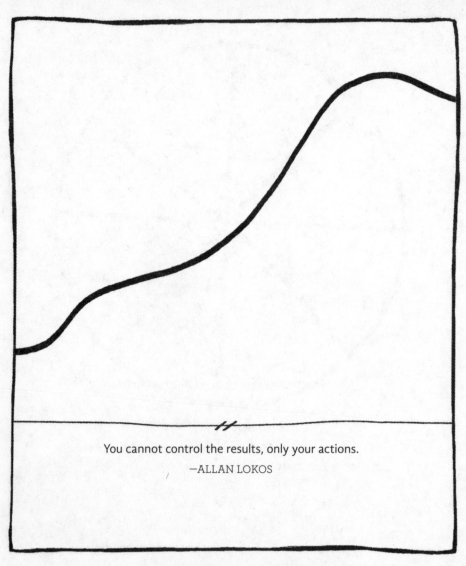

You cannot control the results, only your actions.

—ALLAN LOKOS

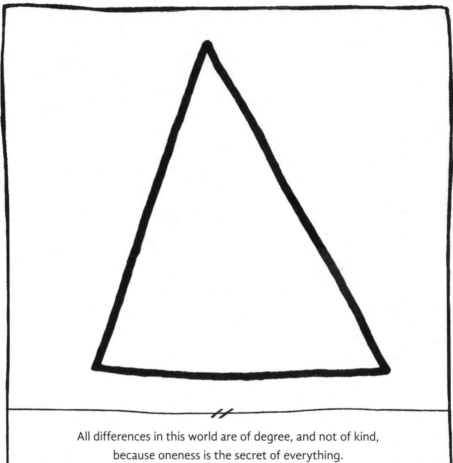

All differences in this world are of degree, and not of kind,
because oneness is the secret of everything.

—SWAMI VIVEKANANDA

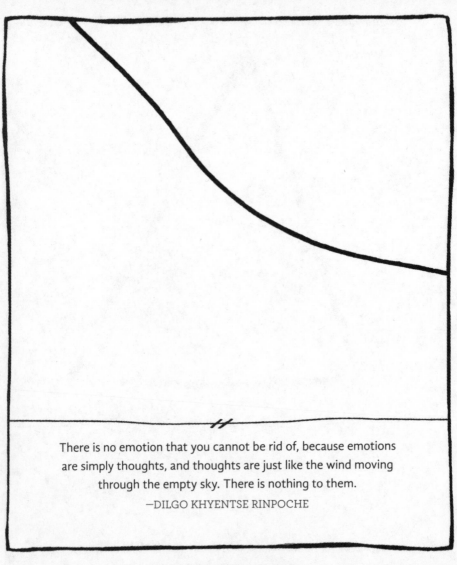

There is no emotion that you cannot be rid of, because emotions
are simply thoughts, and thoughts are just like the wind moving
through the empty sky. There is nothing to them.

—DILGO KHYENTSE RINPOCHE

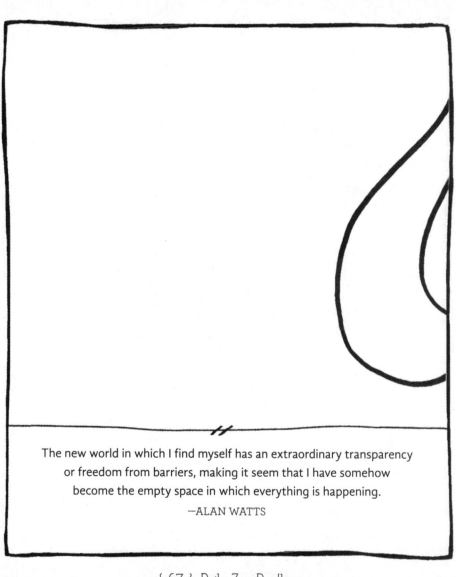

The new world in which I find myself has an extraordinary transparency
or freedom from barriers, making it seem that I have somehow
become the empty space in which everything is happening.

—ALAN WATTS

The gentlest thing in the world overcomes the hardest thing
in the world. That which has no substance enters where there
is no space. This shows the value of non-action.

—LAO TZU

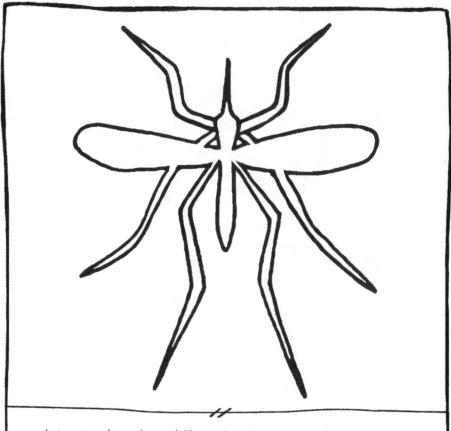

Let us spend one day as deliberately as Nature, and not be thrown off the track by every nutshell and mosquito's wing that falls on the rails.

—HENRY DAVID THOREAU

To be awake is to be alive.... How could I have looked him in the face? We must learn to reawaken and keep ourselves awake, not by mechanical aids, but by an infinite expectation of the dawn, which does not forsake us in our soundest sleep.

—HENRY DAVID THOREAU

Be your own light. Be your own refuge. Confide in nothing outside of yourself. Hold fast to Truth that it may be your guide. Hold fast to Truth that it may be your protector.

—BUDDHA

The human mind, in its never-ending changes, is like the flowing water of river or the burning flame of a candle; like an ape, it is forever jumping about, not ceasing for even a moment. A wise man, seeing and hearing such, should break away from any attachment to body or mind.

—BUDDHA (as quoted by Bukkyo Dendo Kyokai)

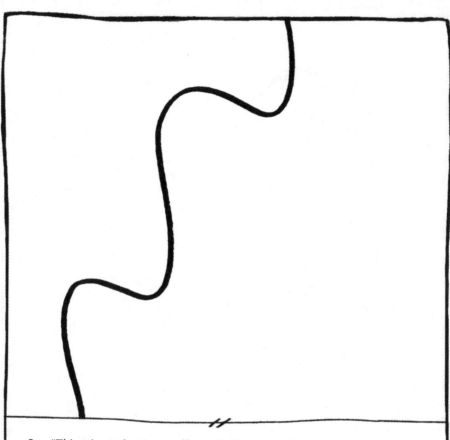

Say, "This misery that I am suffering is of my own doing, and that very thing proves that it will have to be undone by me alone." That which I created, I can demolish; that which is created by someone else, I shall never be able to destroy.

—SWAMI VIVEKANANDA

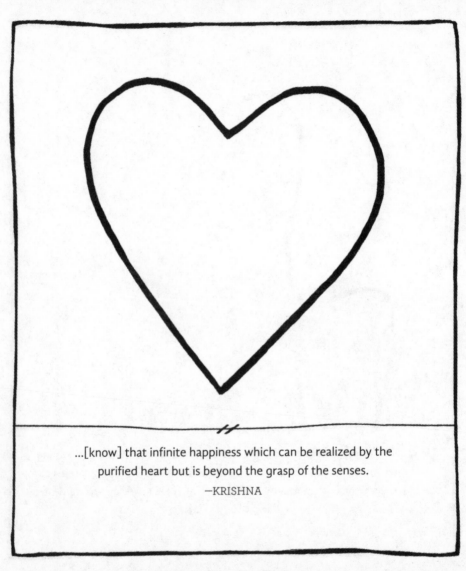

...[know] that infinite happiness which can be realized by the
purified heart but is beyond the grasp of the senses.

—KRISHNA

Anger corrupts, as weeds choke a field. Be free of
anger, and honor those who are also free.

—BUDDHA

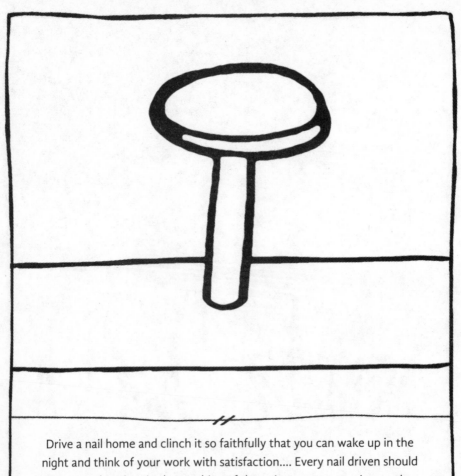

Drive a nail home and clinch it so faithfully that you can wake up in the night and think of your work with satisfaction.... Every nail driven should be as another rivet in the machine of the universe, you carrying on the work. Rather than love, than money, than fame, give me truth.

—HENRY DAVID THOREAU

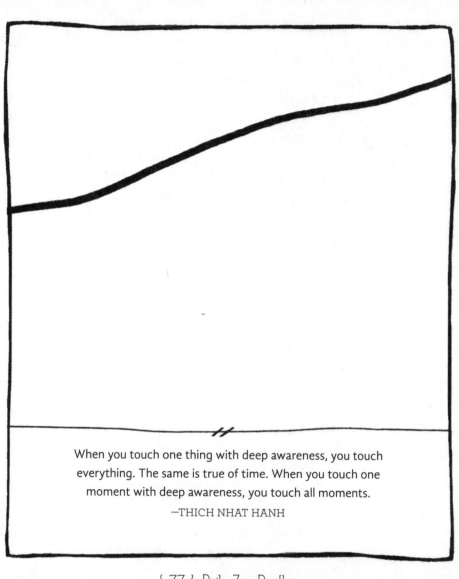

When you touch one thing with deep awareness, you touch everything. The same is true of time. When you touch one moment with deep awareness, you touch all moments.

—THICH NHAT HANH

To go beyond samsara and nirvana, we will need the two wings
of emptiness and compassion. From now on, let us use these
two wings to fly fearlessly into the sky of the life to come.

—DILGO KHYENTSE RINPOCHE

Although we always make the light of the Universal Self foggy and dull because of the clouds which are the ideas of our small self, we can open our eyes to the vital life of the Universal Self by doing zazen and letting go of these ideas.

—KOSHO UCHIYAMA

By sticking to notions of "I" and "mine" and blindly following
the feelings of attraction and repulsion to which these
notions give rise, we accumulate negative karma.

—DILGO KHYENTSE RINPOCHE

He who while fully attached of his body, desires to realize Self, prepares to cross a river on the back of a crocodile, mistaking it for a piece of wood.

—HINDU PROVERB

The deeper the search in the mine of truth the richer
the discovery of the gems buried there.

—MAHATMA GANDHI

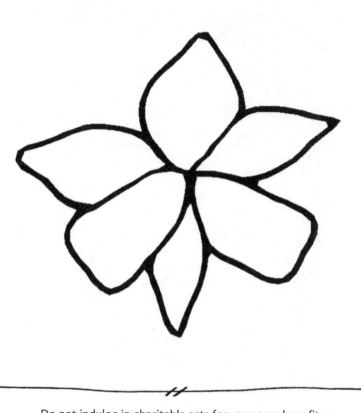

Do not indulge in charitable acts for your own benefit.
Love them for the happiness they bring to others.

—BUDDHA

Life is a good teacher and a good friend. Things are always in transition, if we could only realize it. Nothing ever sums itself up in the way that we like to dream about. The off-center, in-between state is an ideal situation, a situation in which we don't get caught and we can open our hearts and minds beyond limit.

—PEMA CHÖDRÖN

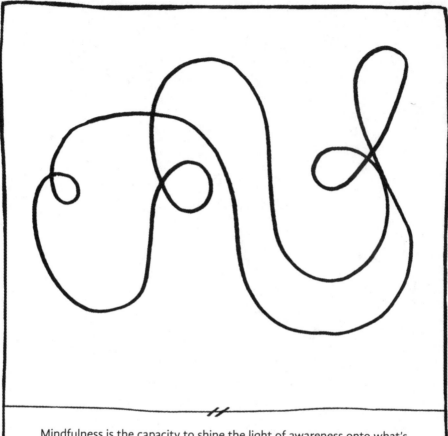

Mindfulness is the capacity to shine the light of awareness onto what's going on here and now. Mindfulness is the heart of meditation practice.

—THICH NHAT HANH

Genius is a light which makes the darkness visible, like the lightning's flash, which perchance shatters the temple of knowledge itself,—and not a taper lighted at the hearth-stone of the race, which pales before the light of common day.

—HENRY DAVID THOREAU

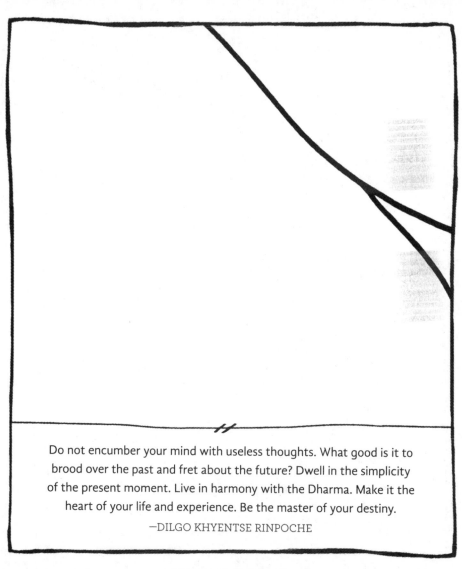

Do not encumber your mind with useless thoughts. What good is it to brood over the past and fret about the future? Dwell in the simplicity of the present moment. Live in harmony with the Dharma. Make it the heart of your life and experience. Be the master of your destiny.

—DILGO KHYENTSE RINPOCHE

May the sound of this bell penetrate deeply into the cosmos. In even the darkest spots, may living beings hear it clearly so their suffering will cease, understanding arise in their hearts, and they can transcend the path of anxiety and sorrow.

—THICH NHAT HANH

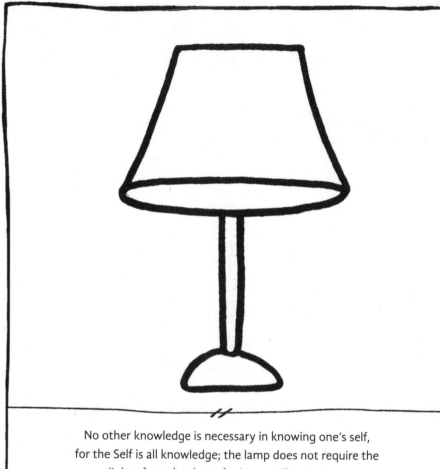

No other knowledge is necessary in knowing one's self,
for the Self is all knowledge; the lamp does not require the
light of another lamp for its own illumination.

—HINDU PROVERB

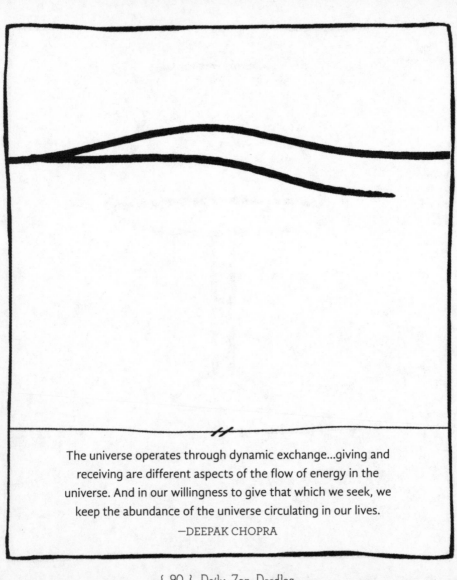

The universe operates through dynamic exchange...giving and receiving are different aspects of the flow of energy in the universe. And in our willingness to give that which we seek, we keep the abundance of the universe circulating in our lives.

—DEEPAK CHOPRA

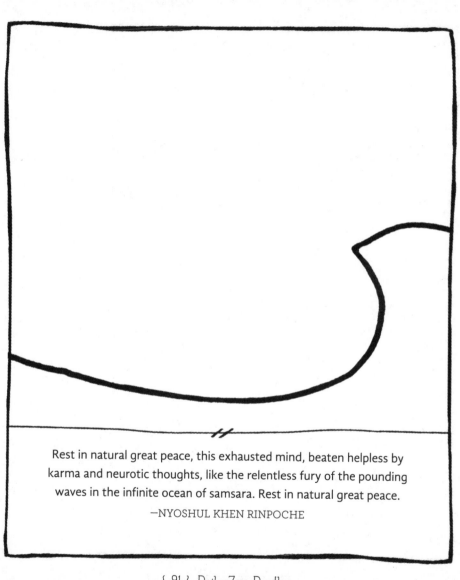

Rest in natural great peace, this exhausted mind, beaten helpless by karma and neurotic thoughts, like the relentless fury of the pounding waves in the infinite ocean of samsara. Rest in natural great peace.

—NYOSHUL KHEN RINPOCHE

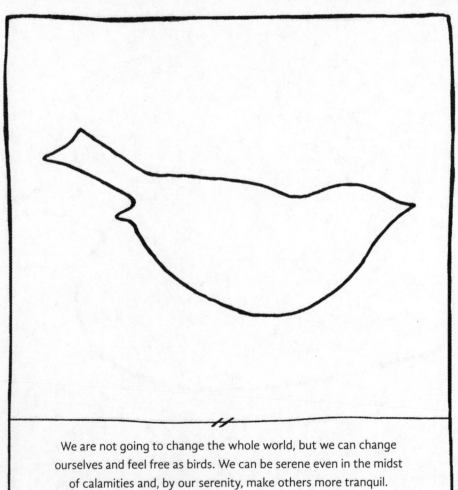

We are not going to change the whole world, but we can change ourselves and feel free as birds. We can be serene even in the midst of calamities and, by our serenity, make others more tranquil.

—SWAMI SATCHIDANANDA (interpreting Patanjali)

Walk as if you are kissing the Earth with your feet.
—THICH NHAT HANH

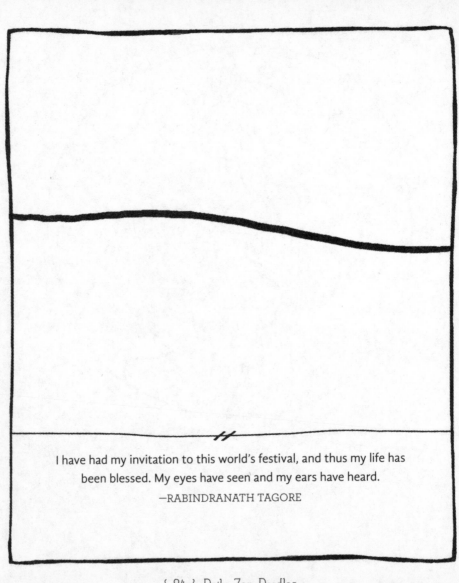

I have had my invitation to this world's festival, and thus my life has been blessed. My eyes have seen and my ears have heard.

—RABINDRANATH TAGORE

When goodness is lost, there is morality. When morality is lost, there is ritual. Ritual is the husk of true faith, the beginning of chaos.

—LAO TZU

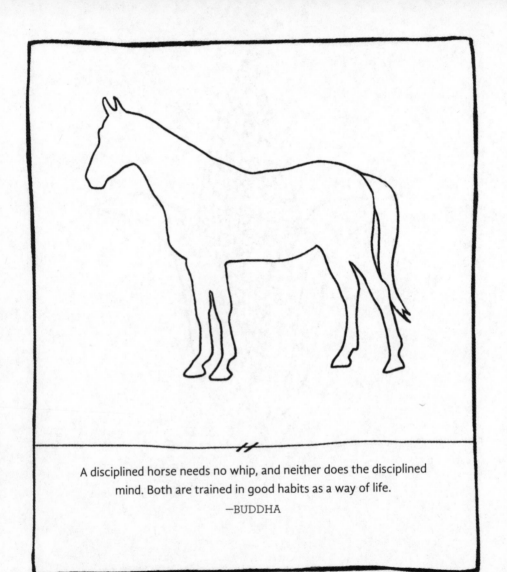

A disciplined horse needs no whip, and neither does the disciplined mind. Both are trained in good habits as a way of life.

—BUDDHA

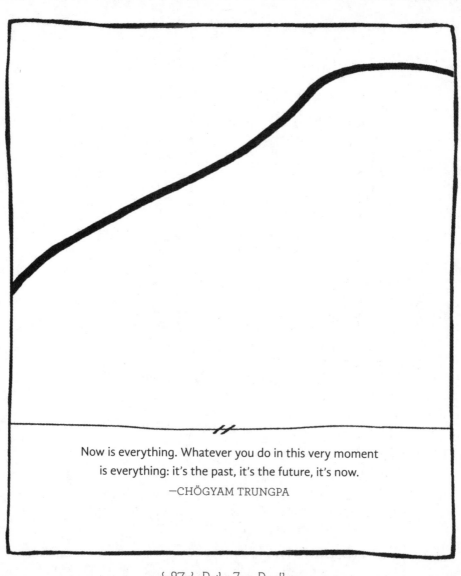

Now is everything. Whatever you do in this very moment
is everything: it's the past, it's the future, it's now.
—CHÖGYAM TRUNGPA

We are like children building a sand castle. We're willing to attack if others threaten to hurt it. Yet...we know that the tide will inevitably come in and sweep the sand castle away. The trick is to enjoy it fully but without clinging, and when the time comes, let it dissolve back into the sea.

—PEMA CHÖDRÖN

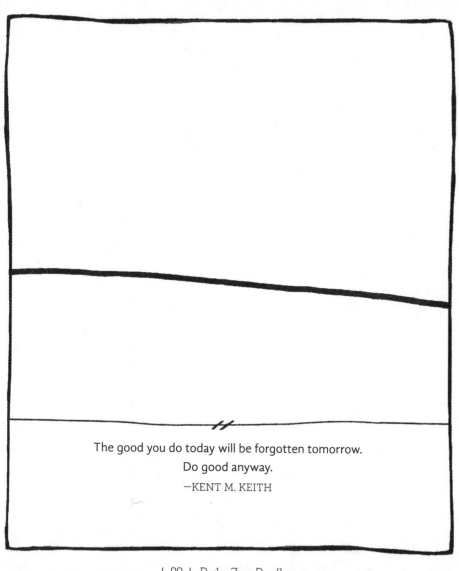

The good you do today will be forgotten tomorrow.
Do good anyway.
—KENT M. KEITH

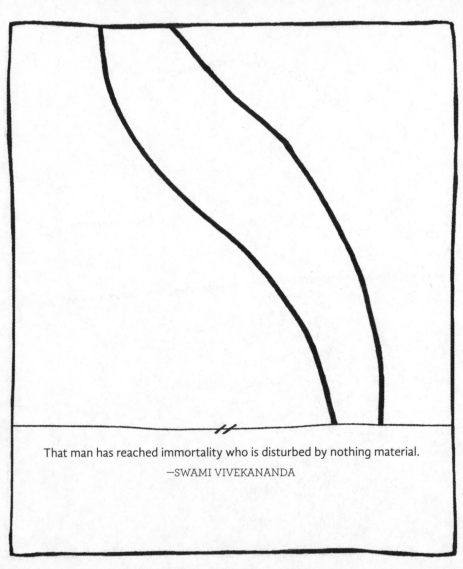

That man has reached immortality who is disturbed by nothing material.

—SWAMI VIVEKANANDA

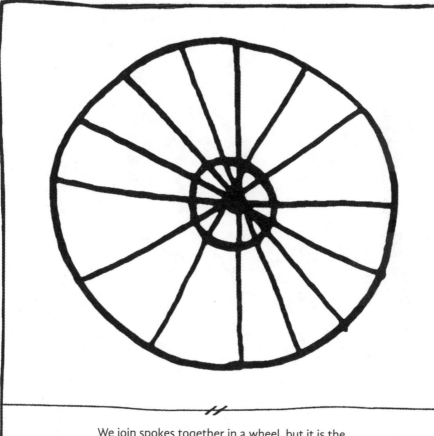

We join spokes together in a wheel, but it is the
center hole that makes the wagon move.

—LAO TZU

If the stars should appear one night in a thousand years, how would men believe and adore; and preserve for many generations the remembrance of the city of God which had been shown! But every night come out these envoys of beauty, and light the universe with their admonishing smile.

—RALPH WALDO EMERSON

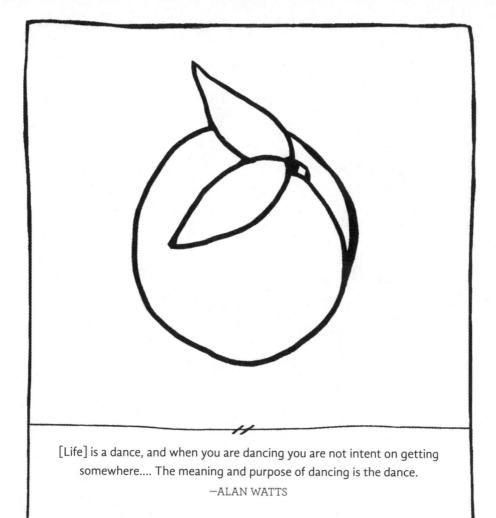

[Life] is a dance, and when you are dancing you are not intent on getting somewhere.... The meaning and purpose of dancing is the dance.

—ALAN WATTS

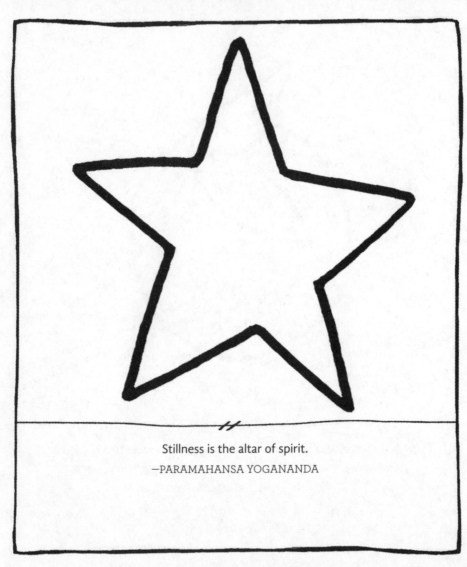

Stillness is the altar of spirit.
—PARAMAHANSA YOGANANDA

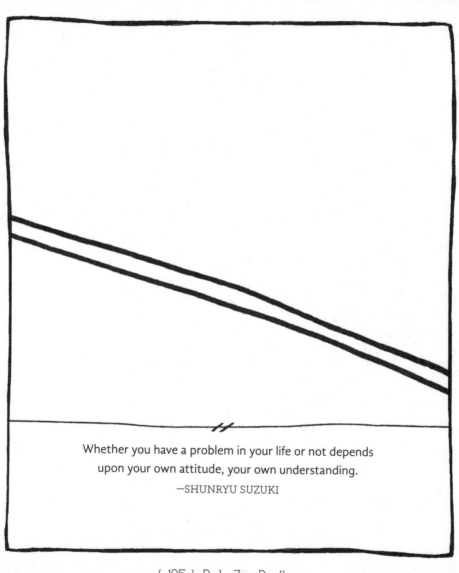

Whether you have a problem in your life or not depends
upon your own attitude, your own understanding.
—SHUNRYU SUZUKI

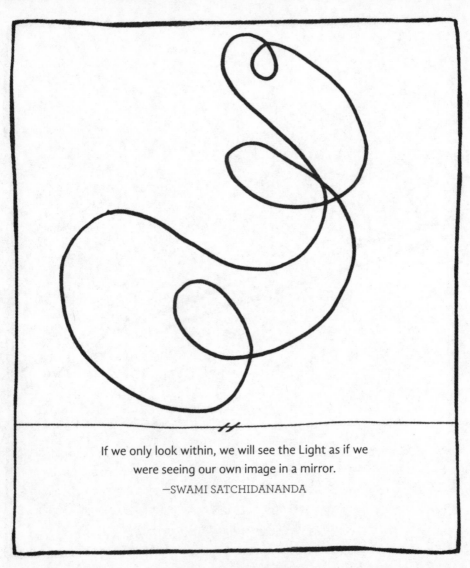

If we only look within, we will see the Light as if we were seeing our own image in a mirror.

—SWAMI SATCHIDANANDA

Blossoms come about because of a series of conditions that lead up to their blooming. Leaves are blown away because a series of conditions lead up to it. Blossoms do not appear independently, nor does a leaf fall of itself, out of its season. So everything has its coming forth and passing away.

—BUDDHA (as quoted by Bukkyo Dendo Kyokai)

Never mind failures; they are quite natural, they are the beauty of life, these failures. What would life be without them? It would not be worth having if it were not for struggles. Where would be the poetry of life? Never mind the struggles, the mistakes. I never heard a cow tell a lie, but it is only a cow—never a man.

—SWAMI VIVEKANANDA

When the mind is ready for some reasons or others, a bird flies or a bell rings, and you at once return to your original home; that is, you discover your now real Self. From the very beginning nothing has been kept from you, all that you wished to see has been there all the time before you.

—SHUNRYU SUZUKI

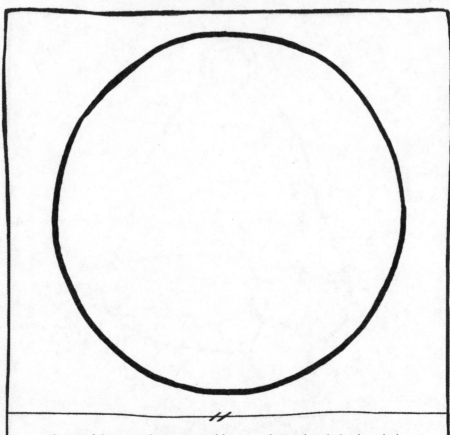

If powerful men and women could center themselves in it, the whole world would be transformed by itself, in its natural rhythms. People would be content with their simple, everyday lives, in harmony, and free of desire. When there is no desire, all things are at peace.

—LAO TZU

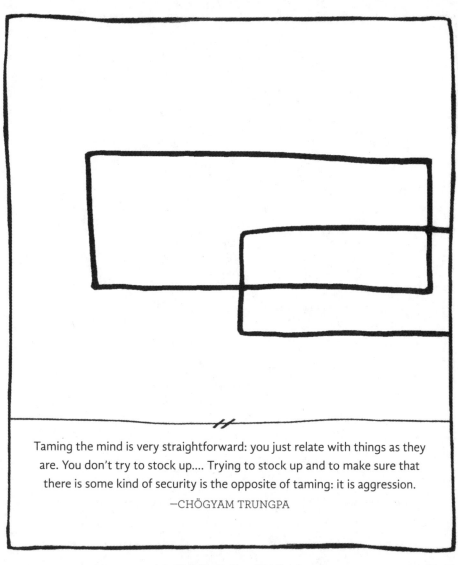

Taming the mind is very straightforward: you just relate with things as they are. You don't try to stock up.... Trying to stock up and to make sure that there is some kind of security is the opposite of taming: it is aggression.

—CHÖGYAM TRUNGPA

Whatever words we utter should be chosen with care because people will hear them and be influenced by them for good or ill.... We must not let wild words pass our lips lest they arouse feelings of anger and hatred. The words we speak should always be words of sympathy and wisdom.

—BUDDHA (as quoted by Bukkyo Dendo Kyokai)

As a light belongs to the sun, coldness to water, and heat to fire, so do existence, consciousness, bliss, eternity, immutable purity, belong by nature to That.

—HINDU PROVERB

Dismiss whatever insults your own soul, and your very flesh shall
be a great poem and have the richest fluency not only in its words
but in the silent lines of its lips and face and between the lashes
of your eyes and in every motion and joint of your body.

—WALT WHITMAN

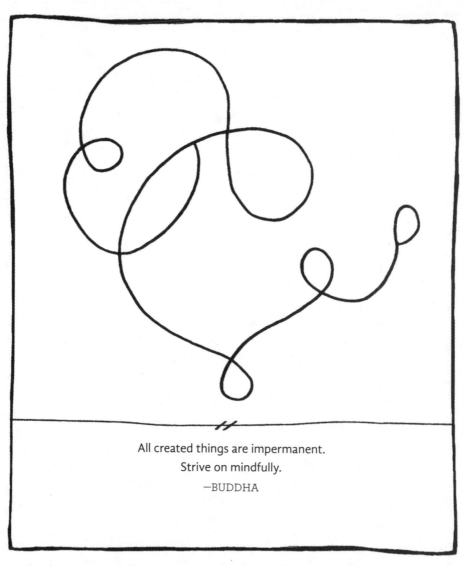

All created things are impermanent.
Strive on mindfully.

—BUDDHA

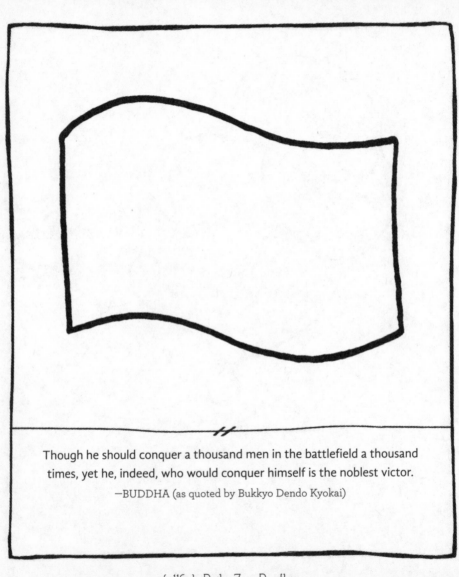

Though he should conquer a thousand men in the battlefield a thousand times, yet he, indeed, who would conquer himself is the noblest victor.

—BUDDHA (as quoted by Bukkyo Dendo Kyokai)

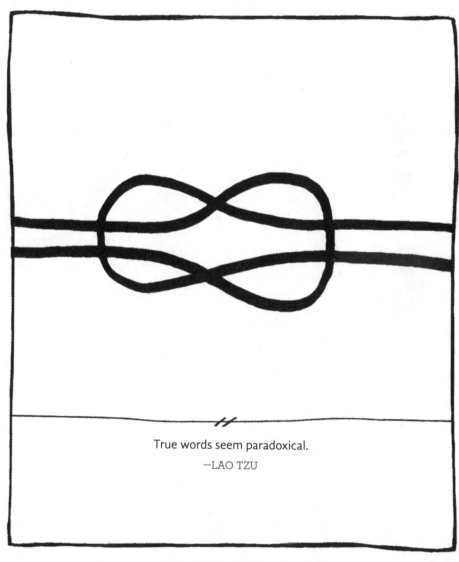

True words seem paradoxical.

—LAO TZU

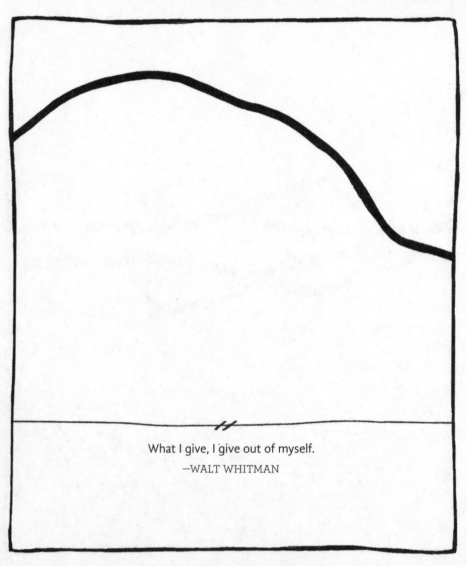

What I give, I give out of myself.

—WALT WHITMAN

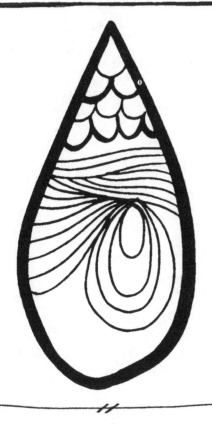

An untrained mind cannot resist the torrent of desire, while one that is
steeped in practice and discipline is able to deflect any temptations, like
a house with a solid roof remaining watertight in a shower of rain.

—BUDDHA

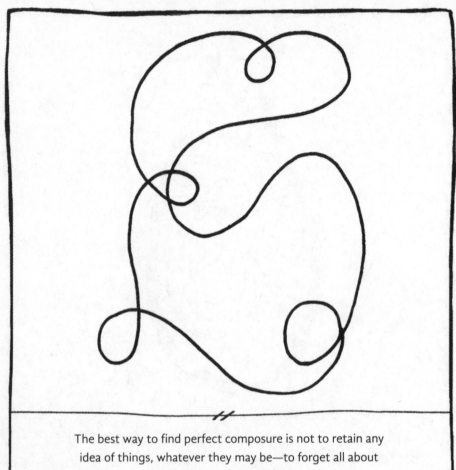

The best way to find perfect composure is not to retain any
idea of things, whatever they may be—to forget all about
them and not leave any trace or shadow of thinking.
—SHUNRYU SUZUKI

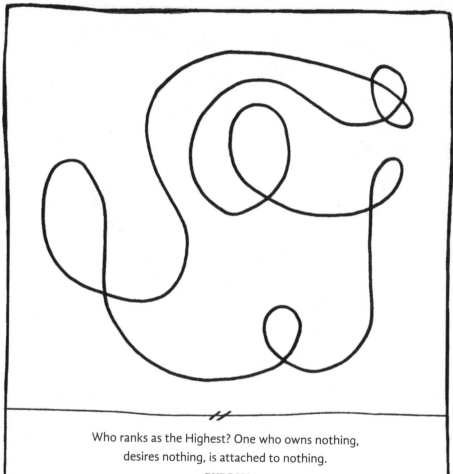

Who ranks as the Highest? One who owns nothing,
desires nothing, is attached to nothing.

—BUDDHA

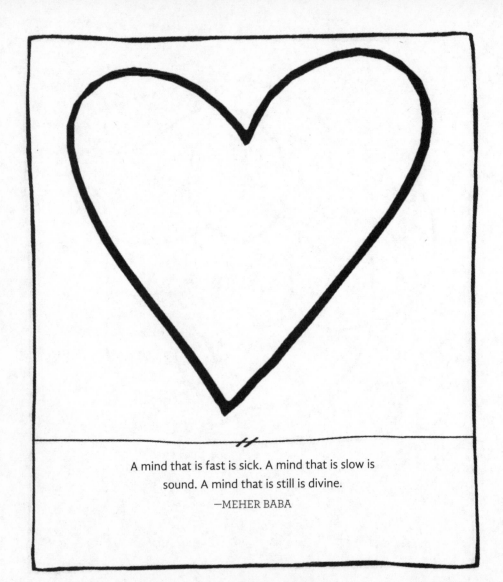

A mind that is fast is sick. A mind that is slow is
sound. A mind that is still is divine.

—MEHER BABA

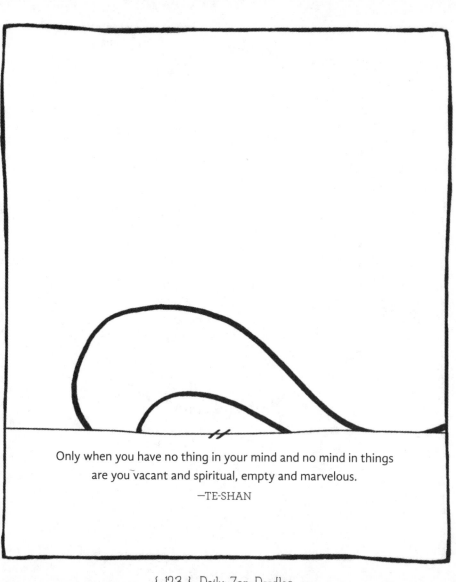

Only when you have no thing in your mind and no mind in things
are you vacant and spiritual, empty and marvelous.

—TE-SHAN

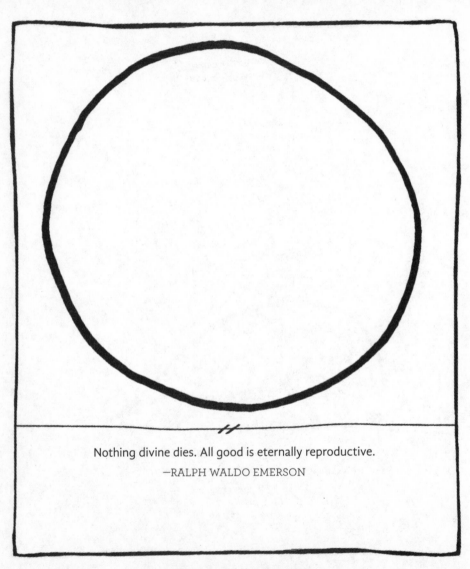

Nothing divine dies. All good is eternally reproductive.

—RALPH WALDO EMERSON

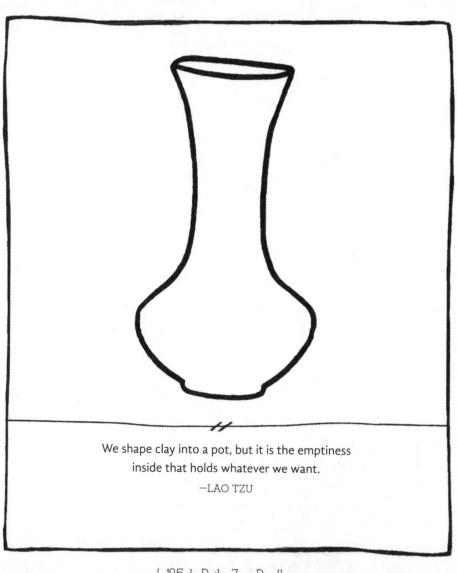

We shape clay into a pot, but it is the emptiness
inside that holds whatever we want.

—LAO TZU

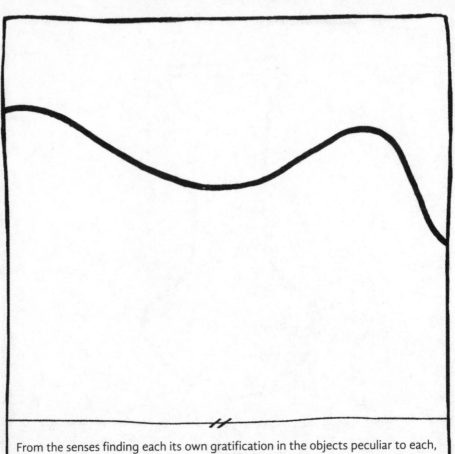

From the senses finding each its own gratification in the objects peculiar to each, there arises no real happiness, but only a temporary allaying of the fever of the mind. It is vain, therefore, to grope for any real happiness in the world of objects.

—HINDU PROVERB

Men are born soft and supple; dead, they are stiff and hard. Plants are born tender and pliant; dead, they are brittle and dry. Thus whoever is stiff and inflexible is a disciple of death. Whoever is soft and yielding is a disciple of life. The hard and stiff will be broken. The soft and supple will prevail.

—LAO TZU

The wave is the same as the ocean, though it is not the whole ocean. So each wave of creation is a part of the eternal Ocean of Spirit. The Ocean can exist without the waves, but the waves cannot exist without the Ocean.

—PARAMAHANSA YOGANANDA

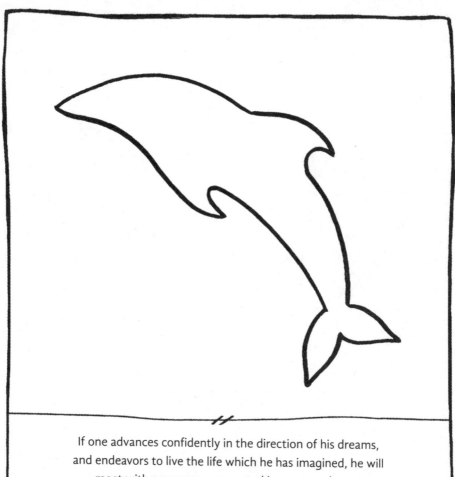

If one advances confidently in the direction of his dreams,
and endeavors to live the life which he has imagined, he will
meet with a success unexpected in common hours.

—HENRY DAVID THOREAU

Those who wish to sit, shut their eyes, and meditate to know if the world's true or lies, may do so. It's their choice. But I meanwhile with hungry eyes that can't be satisfied shall take a look at the world in broad daylight.

—RABINDRANATH TAGORE

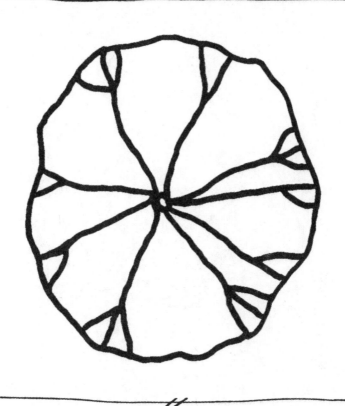

live in this world like a lotus leaf, which grows in water
but is never moistened by the water.

—KRISHNA

The thoughtless person allows desire to grow like a creeper. From one birth to the next, like a monkey in a forest swinging from tree to tree, it goes on.

—BUDDHA

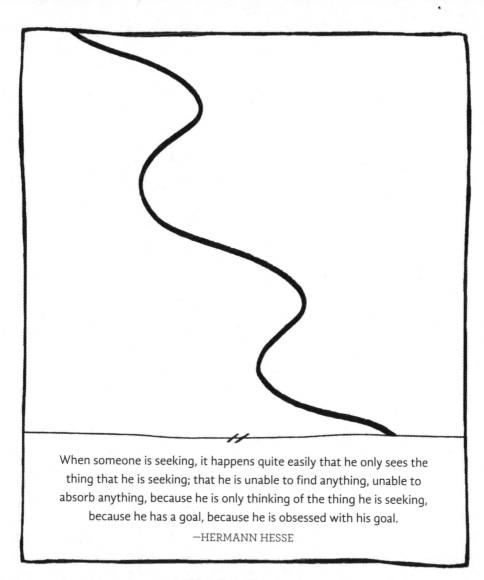

When someone is seeking, it happens quite easily that he only sees the thing that he is seeking; that he is unable to find anything, unable to absorb anything, because he is only thinking of the thing he is seeking, because he has a goal, because he is obsessed with his goal.

—HERMANN HESSE

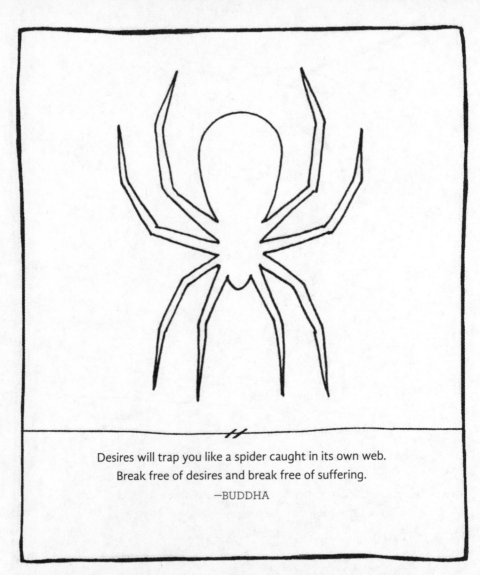

Desires will trap you like a spider caught in its own web.
Break free of desires and break free of suffering.

—BUDDHA

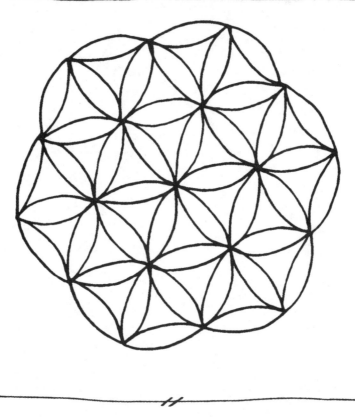

Making good use of our limited time—the limited time
from birth to death, as well as our limited time each day—
is the key to developing inner steadiness and calm.

—PEMA CHÖDRÖN

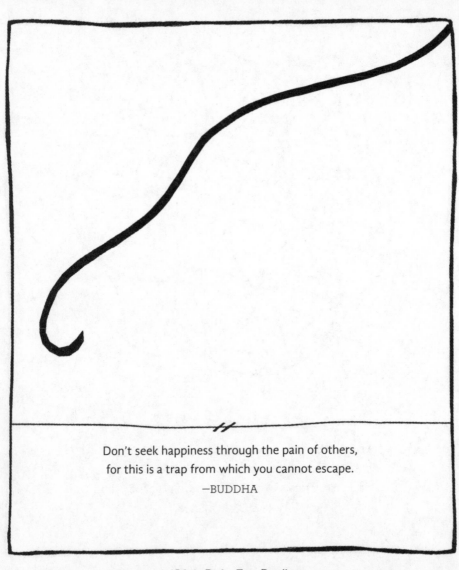

Don't seek happiness through the pain of others,
for this is a trap from which you cannot escape.

—BUDDHA

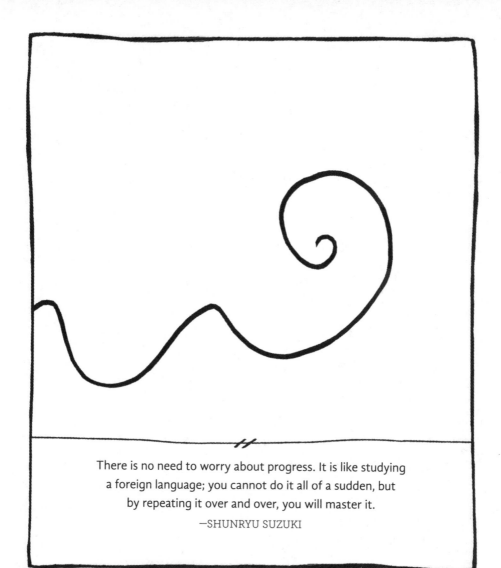

There is no need to worry about progress. It is like studying
a foreign language; you cannot do it all of a sudden, but
by repeating it over and over, you will master it.
—SHUNRYU SUZUKI

The Master observes the world but trusts his inner vision. He allows things to come and go. His heart is open as the sky.

—LAO TZU

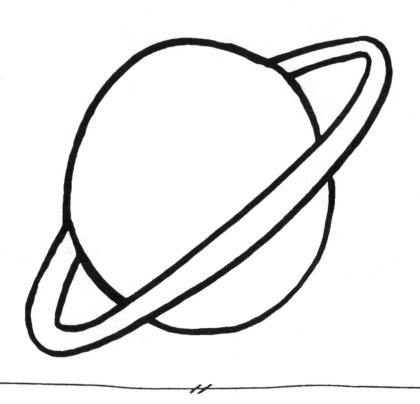

The important thing is: how much less you think of the body, of yourself as matter—as dead, dull, insentient matter; how much more you think of yourself as shining immortal being.

—SWAMI VIVEKANANDA

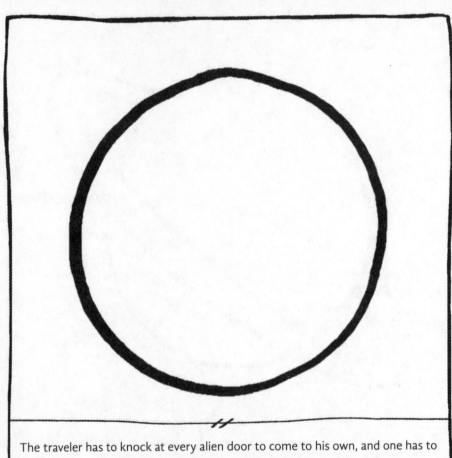

The traveler has to knock at every alien door to come to his own, and one has to wander through all the outer worlds to reach the innermost shrine at the end.

—RABINDRANATH TAGORE

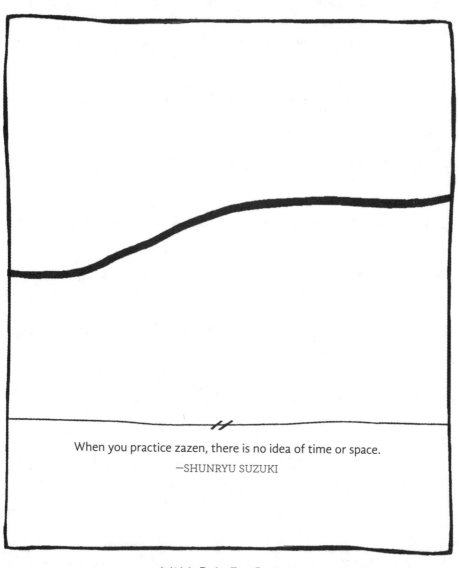

When you practice zazen, there is no idea of time or space.

—SHUNRYU SUZUKI

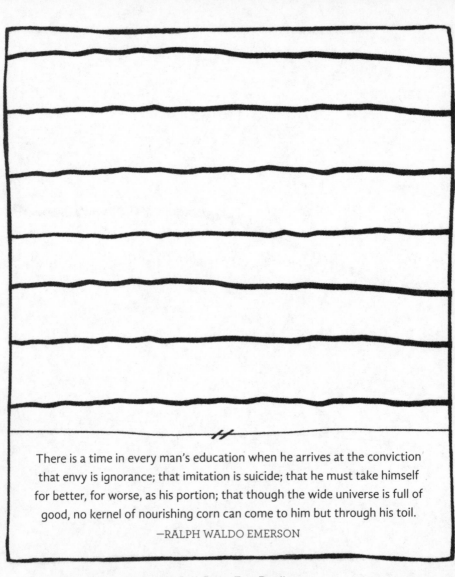

There is a time in every man's education when he arrives at the conviction that envy is ignorance; that imitation is suicide; that he must take himself for better, for worse, as his portion; that though the wide universe is full of good, no kernel of nourishing corn can come to him but through his toil.

—RALPH WALDO EMERSON

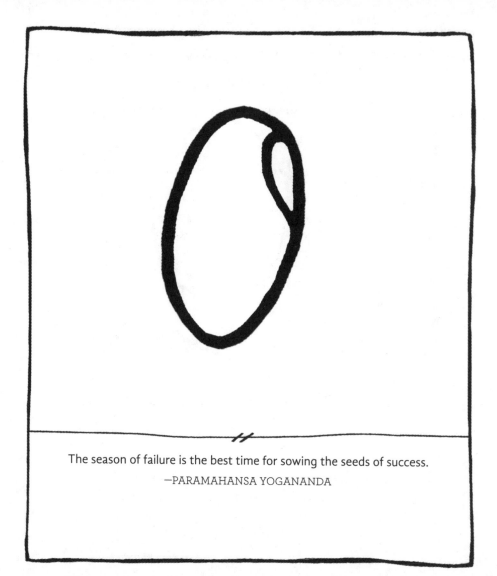

The season of failure is the best time for sowing the seeds of success.

—PARAMAHANSA YOGANANDA

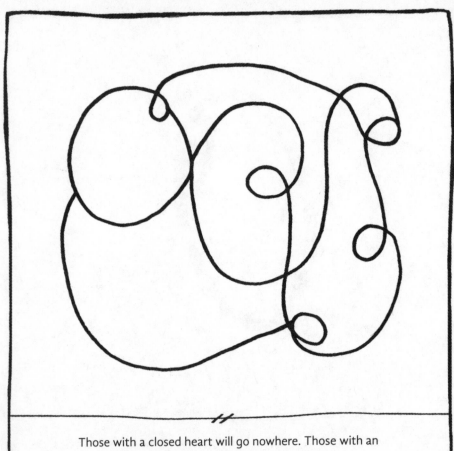

Those with a closed heart will go nowhere. Those with an
open heart in all things will find great happiness.

—BUDDHA

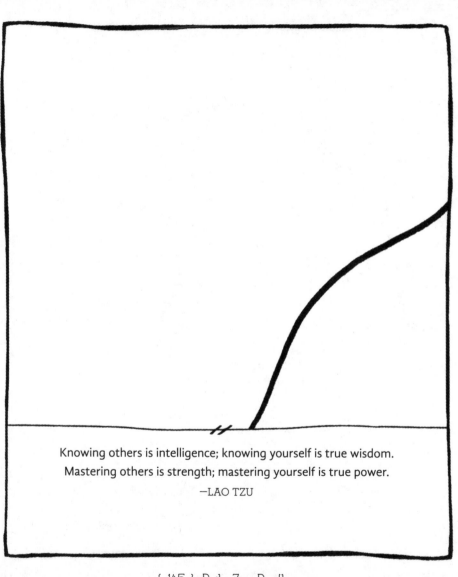

Knowing others is intelligence; knowing yourself is true wisdom.
Mastering others is strength; mastering yourself is true power.

—LAO TZU

As a hawk or an eagle having soared high in the air, wings its
way back to its resting place, being so far fatigued, so does
the soul, having experienced the phenomenal, return to Itself
where it can sleep beyond all desires, beyond all dreams.

—HINDU PROVERB

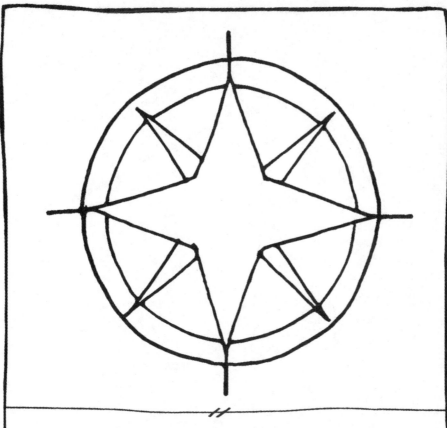

Every man has to learn the points of compass again as often as he awakes, whether from sleep or any abstraction. Not till we are lost, in other words not till we have lost the world, do we begin to find ourselves, and realize where we are and the infinite extent of our relations.

—HENRY DAVID THOREAU

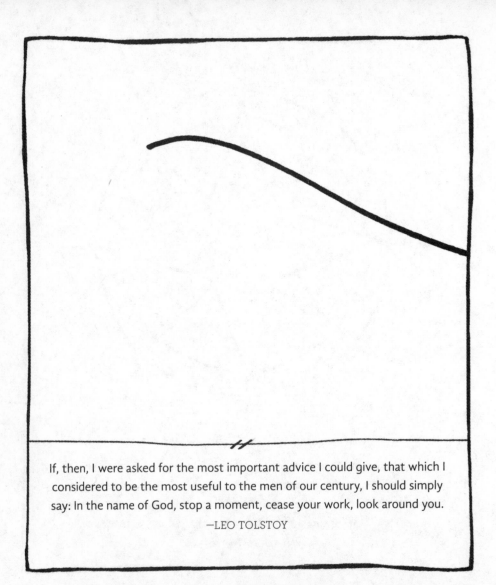

If, then, I were asked for the most important advice I could give, that which I considered to be the most useful to the men of our century, I should simply say: In the name of God, stop a moment, cease your work, look around you.

—LEO TOLSTOY

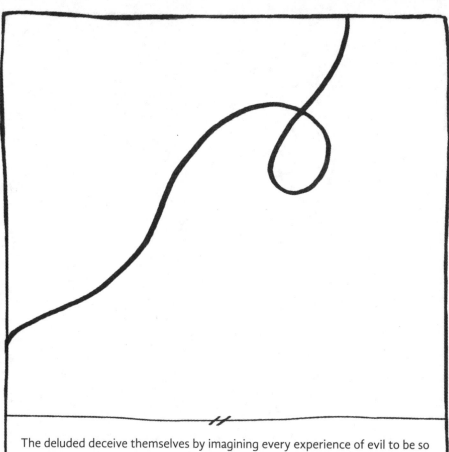

The deluded deceive themselves by imagining every experience of evil to be so much good; but in birth, death, and limitation, the wise never fail to perceive the evil that conceals itself under the inviting form of objects.... The smallest happiness, in the real sense of the word, is no way possible in any thing.

—HINDU PROVERB

You are what you think. Pain will follow bad thoughts
as certain as happiness will follow good ones.

—BUDDHA

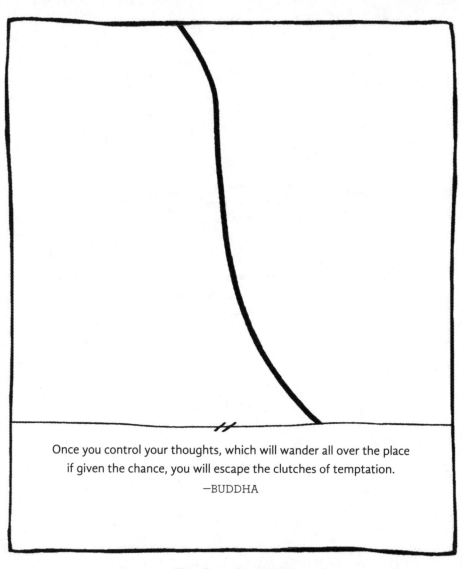

Once you control your thoughts, which will wander all over the place
if given the chance, you will escape the clutches of temptation.

—BUDDHA

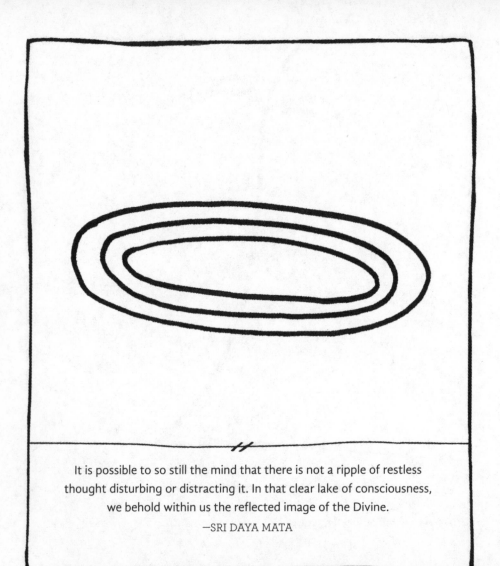

It is possible to so still the mind that there is not a ripple of restless thought disturbing or distracting it. In that clear lake of consciousness, we behold within us the reflected image of the Divine.

—SRI DAYA MATA

If the day and night are such that you greet them with joy, and life emits a fragrance like flowers and sweet-scented herbs, is more elastic, more starry, more immortal—that is your success. All nature is your congratulation, and you have cause momentarily to bless yourself.

—HENRY DAVID THOREAU

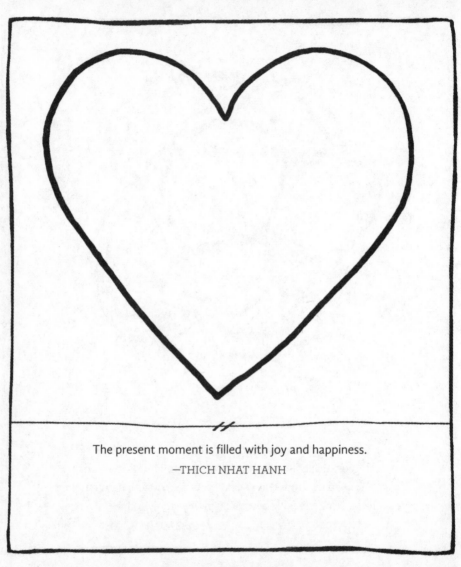

The present moment is filled with joy and happiness.

—THICH NHAT HANH

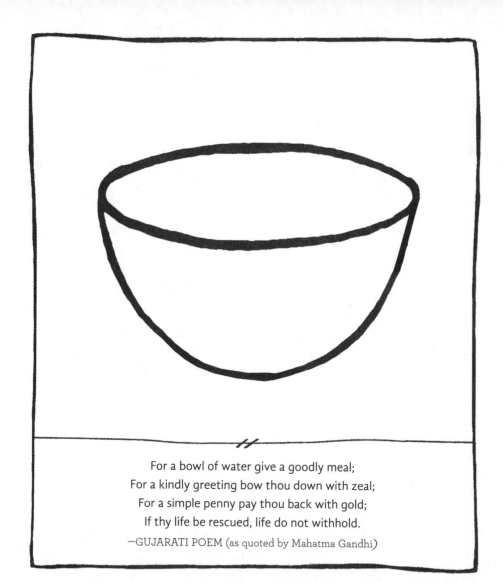

For a bowl of water give a goodly meal;
For a kindly greeting bow thou down with zeal;
For a simple penny pay thou back with gold;
If thy life be rescued, life do not withhold.

—GUJARATI POEM (as quoted by Mahatma Gandhi)

It is something to be able to paint a particular picture, or to carve a statue, and so to make a few objects beautiful; but it is far more glorious to carve and paint the very atmosphere and medium through which we look, which morally we can do.

—HENRY DAVID THOREAU

Nature never wears a mean appearance.

—RALPH WALDO EMERSON

In mindfulness one is not only restful and happy, but alert and awake. Meditation is not evasion; it is a serene encounter with reality.

—THICH NHAT HANH

You may shut the mouth of the bear and the tiger; Ride the lion and play with the cobra; By alchemy you may earn your livelihood; You may wander through the universe incognito; Make vassals of the gods; be ever youthful; You may walk on water and live in fire; But control of the mind is better and more difficult.

—THAYUMANAVAR (as quoted in *Autobiography of a Yogi*)

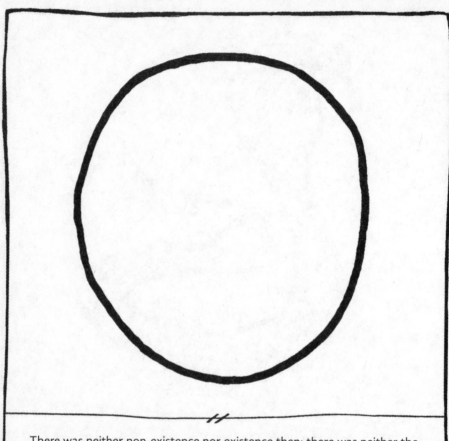

There was neither non-existence nor existence then; there was neither the realm of space nor the sky which is beyond. What stirred? Where? In whose protection? Was there water, bottomlessly deep? There was neither death nor immortality then. There was no distinguishing sign of night nor of day.

—THE RIG VEDA

What is a good man but a bad man's teacher? What is a bad man but a good man's job? If you don't understand this, you will get lost, however intelligent you are. It is the great secret.

—LAO TZU

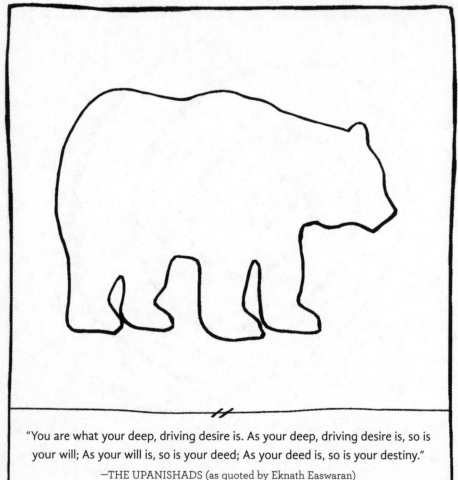

"You are what your deep, driving desire is. As your deep, driving desire is, so is
your will; As your will is, so is your deed; As your deed is, so is your destiny."

—THE UPANISHADS (as quoted by Eknath Easwaran)

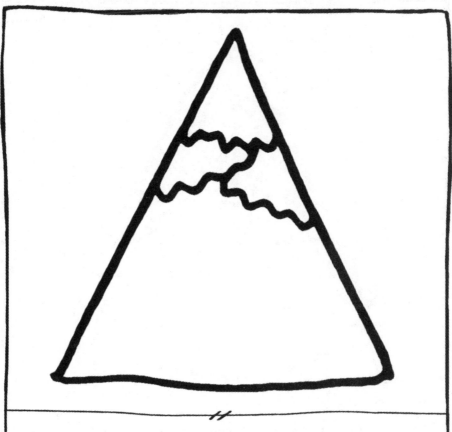

When we are at home with ourselves, we are at home everywhere in the world.

—EKNATH EASWARAN

I thought that my voyage had come to its end at the last limit of my power...but I find that thy will knows no end in me. And when old words die out on the tongue, new melodies break forth from the heart; and where the old tracks are lost, new country is revealed with its wonders.

—RABINDRANATH TAGORE

Conscious breathing is my anchor.

—THICH NHAT HANH

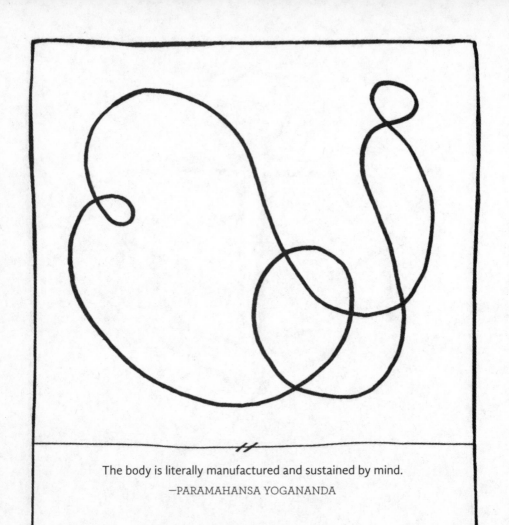

The body is literally manufactured and sustained by mind.

—PARAMAHANSA YOGANANDA

I am the sweet fragrance in the earth and the heat in fire; I am the
life in every creature, and the effort of the spiritual aspirant.
—EKNATH EASWARAN

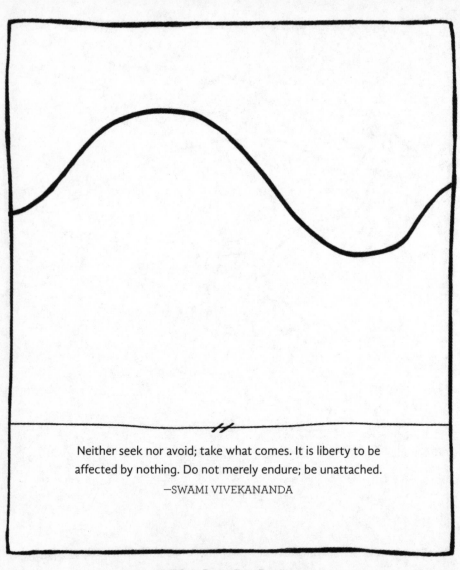

Neither seek nor avoid; take what comes. It is liberty to be affected by nothing. Do not merely endure; be unattached.

—SWAMI VIVEKANANDA

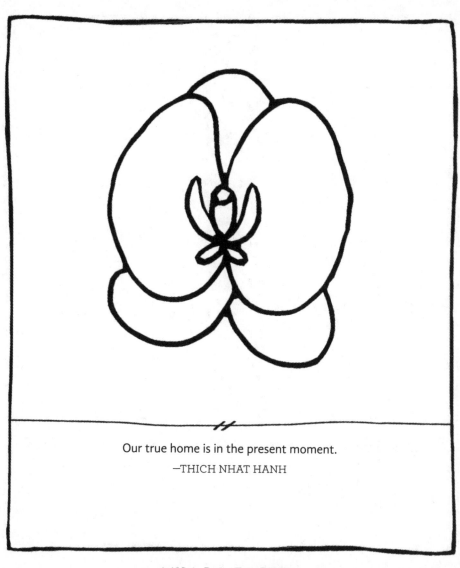

Our true home is in the present moment.

—THICH NHAT HANH

We are all in this together. Our happiness inextricably is tied to that of all beings.
—ALLAN LOKOS

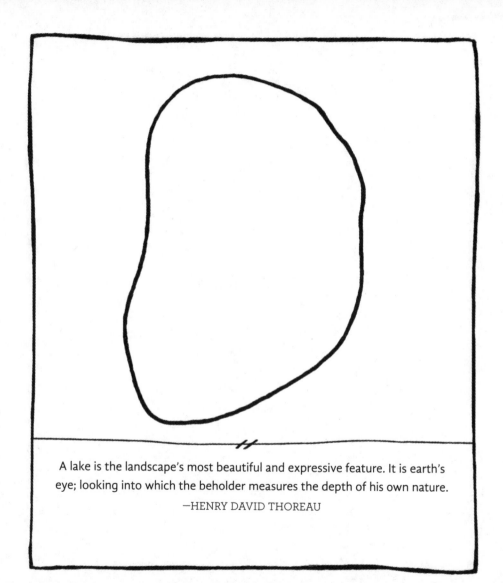

A lake is the landscape's most beautiful and expressive feature. It is earth's eye; looking into which the beholder measures the depth of his own nature.

—HENRY DAVID THOREAU

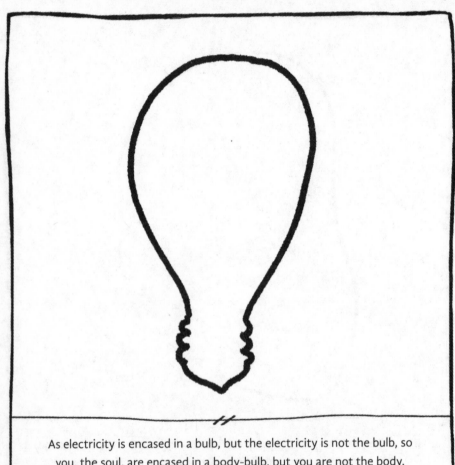

As electricity is encased in a bulb, but the electricity is not the bulb, so you, the soul, are encased in a body-bulb, but you are not the body.

—SRI DAYA MATA

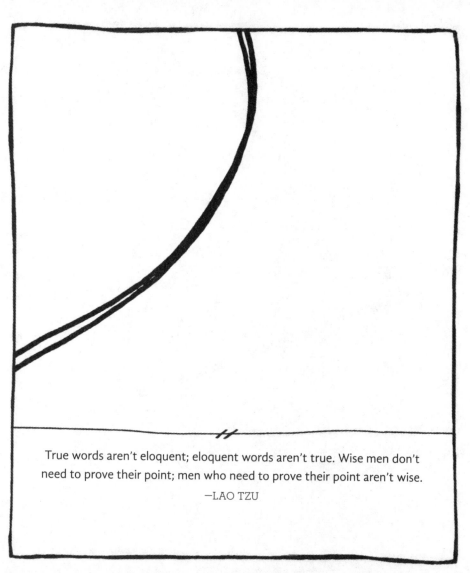

True words aren't eloquent; eloquent words aren't true. Wise men don't need to prove their point; men who need to prove their point aren't wise.

—LAO TZU

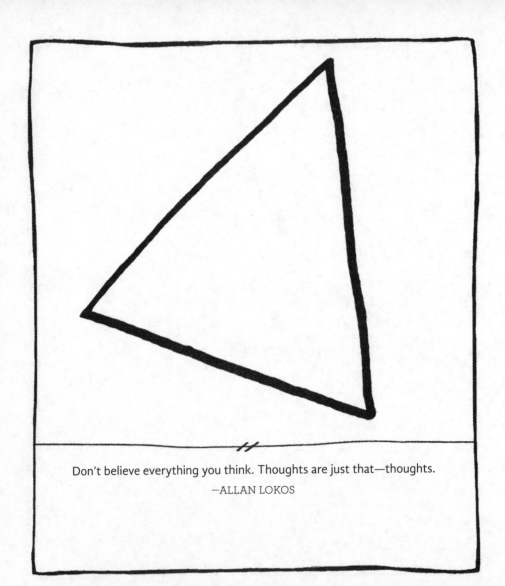

Don't believe everything you think. Thoughts are just that—thoughts.

—ALLAN LOKOS

Thought is all light, and publishes itself to the universe. It will speak, though you were dumb, by its own miraculous organ. It will flow out of your actions, your manners, and your face.

—HENRY DAVID THOREAU

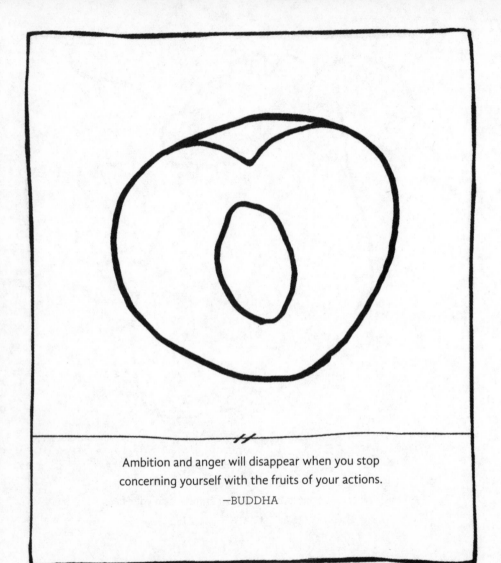

Ambition and anger will disappear when you stop
concerning yourself with the fruits of your actions.

—BUDDHA

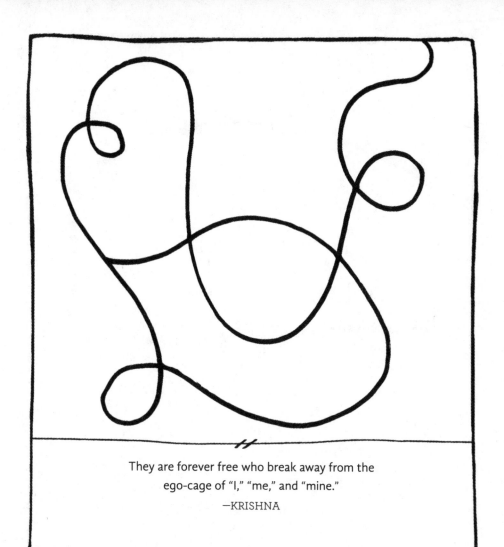

They are forever free who break away from the
ego-cage of "I," "me," and "mine."

—KRISHNA

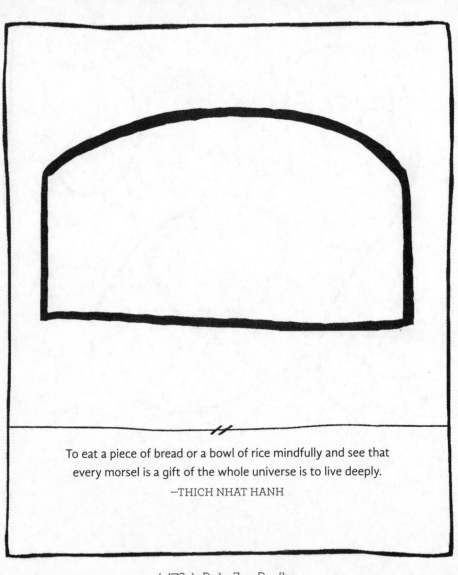

To eat a piece of bread or a bowl of rice mindfully and see that
every morsel is a gift of the whole universe is to live deeply.

—THICH NHAT HANH

You are what your deep, driving desire is.
As your desire is, so is your will.
As your will is, so is your deed.
As your deed is, so is your destiny.
—BRIHADARANYAKA UPANISHAD

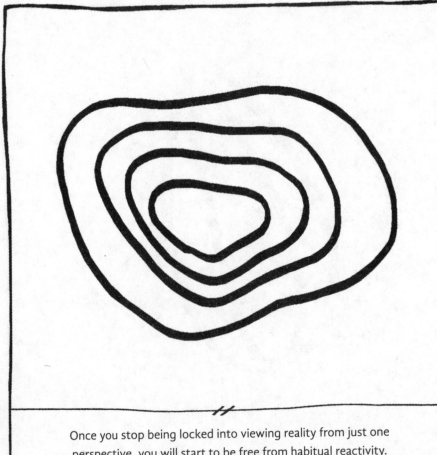

Once you stop being locked into viewing reality from just one perspective, you will start to be free from habitual reactivity.

—STEPHEN RICHARDS

All the powers in the universe are already ours. It is we who have put our hands before our eyes and cry that it is dark.

—SWAMI VIVEKANANDA

True mastery can be gained by letting things go their
own way. It can't be gained by interfering.

—LAO TZU

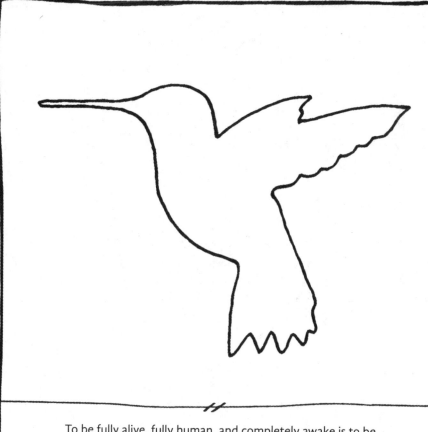

To be fully alive, fully human, and completely awake is to be continually thrown out of the nest. To live fully is to be always in no-man's-land, to experience each moment as completely new and fresh. To live is to be willing to die over and over again.

—PEMA CHÖDRÖN

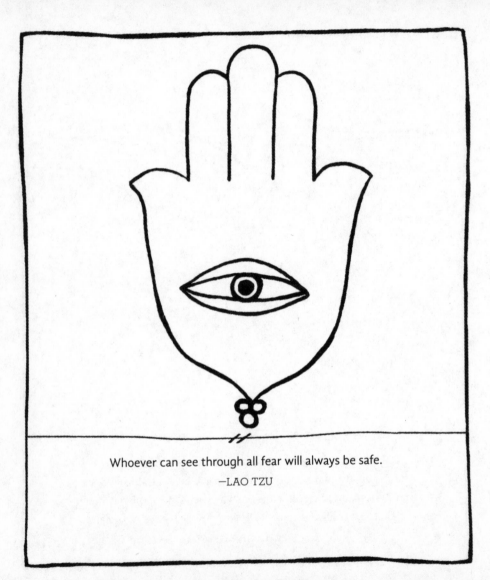

Whoever can see through all fear will always be safe.

—LAO TZU

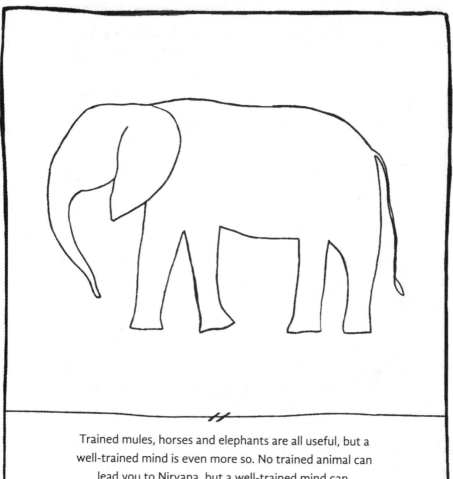

Trained mules, horses and elephants are all useful, but a
well-trained mind is even more so. No trained animal can
lead you to Nirvana, but a well-trained mind can.

—BUDDHA

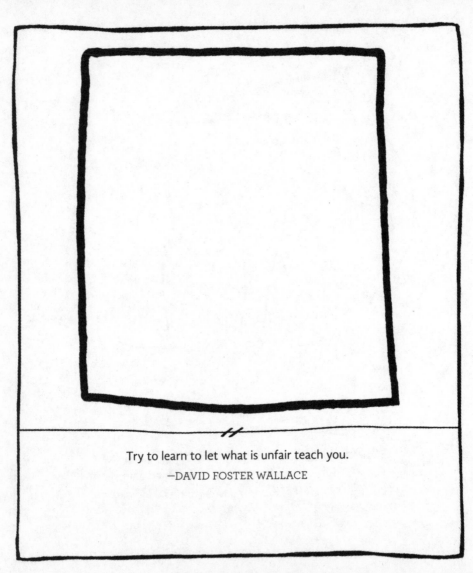

Try to learn to let what is unfair teach you.

—DAVID FOSTER WALLACE

Truth is not a reward for good behavior, nor a prize for passing some tests. It cannot be brought about. It is the primary, the unborn, the ancient source of all that is. You are eligible because you are. You need not merit truth. It is your own....Stand still, be quiet.

—SRI NISARGADATTA MAHARAJ

When you run after your thoughts, you are like a dog chasing a stick; every time a stick is thrown, you run after it.... Be like a lion—who rather than chasing after the stick, turns to face the thrower. One only throws a stick at a lion once.

—DILGO KHYENTSE RINPOCHE

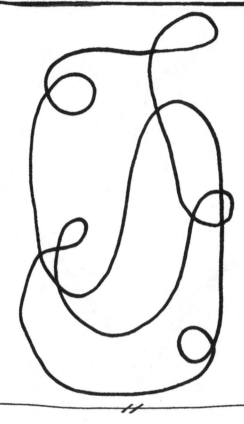

We have the power to wake up, to touch enlightenment from moment to moment, in our very own ordinary and, yes, busy lives. So let's start right now. Peace is *your* every breath.

—THICH NHAT HANH

Enlightened heart is expansive and awake. It is not territorial, and it does not demand that we gather our own flock of egotistic companions. When we look into that quality of basic wakefulness beyond our own territoriality, we find ourselves having a taste of enlightenment for the very first time.

—CHÖGYAM TRUNGPA

The really important kind of freedom involves attention, and awareness, and discipline, and effort, and being able truly to care about other people and to sacrifice for them, over and over.

—DAVID FOSTER WALLACE

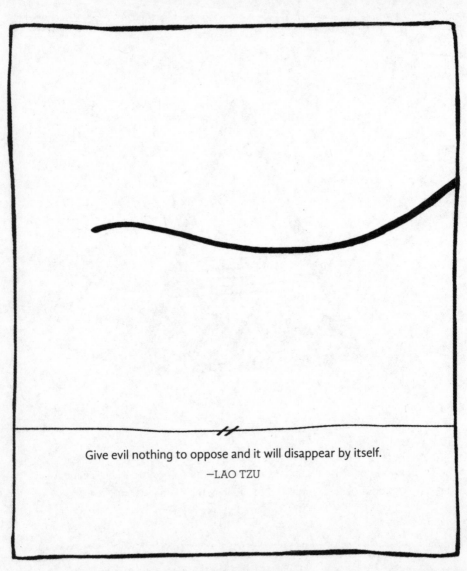

Give evil nothing to oppose and it will disappear by itself.

—LAO TZU

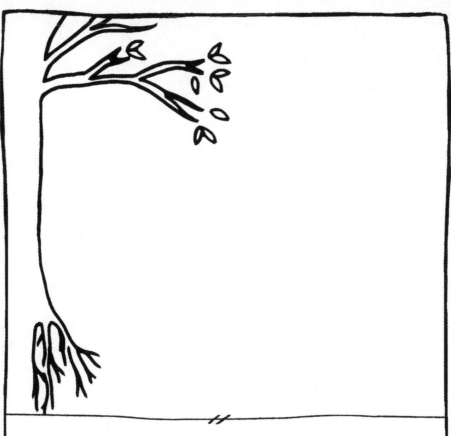

Not agitating the world or by it agitated, he stands above the sway of elation, competition, and fear, accepting life, good and bad, as it comes.

—KRISHNA

As in the sun, all light, there is neither day nor night, so in The Absolute, all light, there is neither knowledge nor ignorance.

—HINDU PROVERB

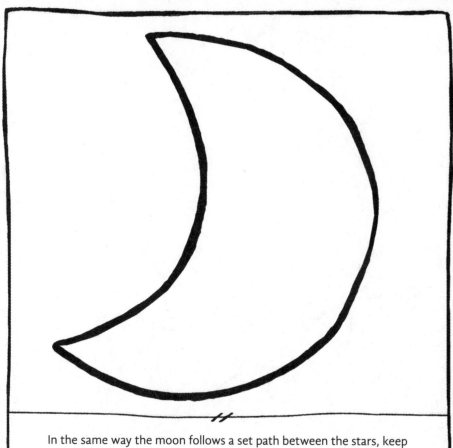

In the same way the moon follows a set path between the stars, keep yourself fixed in the presence of a wise teacher and fellow aspirants.

—BUDDHA

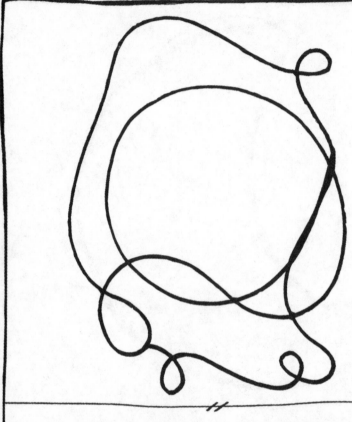

An unenlightened life rises from a mind that is bewildered by its own world of delusion. If we learn that there is no world of delusion outside the mind, the bewildered mind becomes clear; and because we cease to create impure surroundings, we attain Enlightenment.

—BUDDHA (as quoted by Bukkyo Dendo Kyokai)

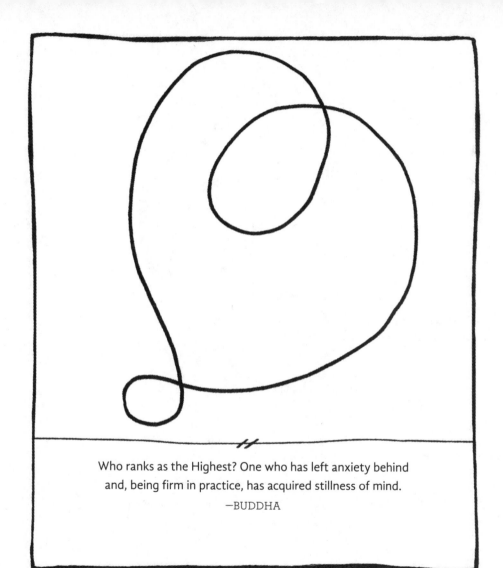

Who ranks as the Highest? One who has left anxiety behind
and, being firm in practice, has acquired stillness of mind.

—BUDDHA

And when old words die out on the tongue, new melodies
break forth from the heart; and where the old tracks are
lost, new country is revealed with its wonders.

—RABINDRANATH TAGORE

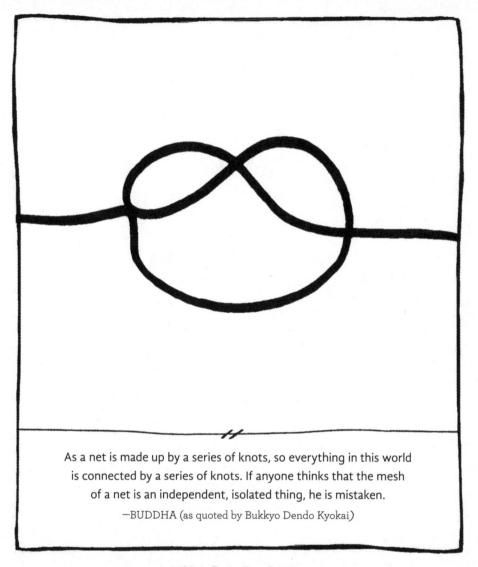

As a net is made up by a series of knots, so everything in this world is connected by a series of knots. If anyone thinks that the mesh of a net is an independent, isolated thing, he is mistaken.

—BUDDHA (as quoted by Bukkyo Dendo Kyokai)

When we are in touch with the highest spirit in
ourselves, we too are a Buddha....
—THICH NHAT HANH

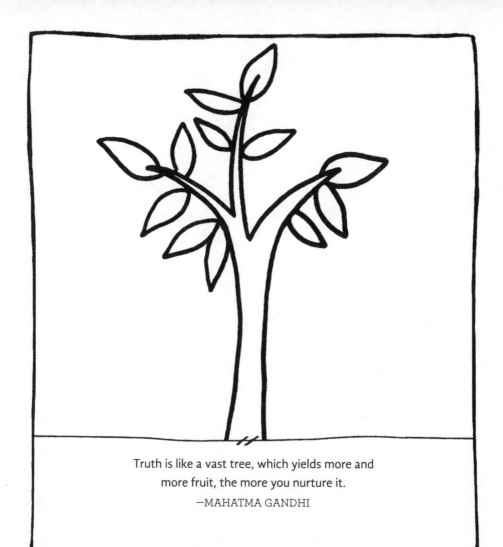

Truth is like a vast tree, which yields more and
more fruit, the more you nurture it.

—MAHATMA GANDHI

When we have found peace within ourselves, peace
and love follow us wherever we go.

—EKNATH ESWARAN

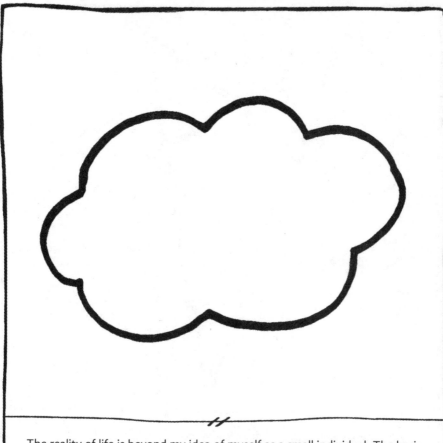

The reality of life is beyond my idea of myself as a small individual. The basic fact is that the Self is living out non-dual life which pervades all living things and everything which exists.... We cause the Self to be clouded over. If we now let go of our thoughts, this reality of life becomes pure and clear.

—KOSHO UCHIYAMA

There shines not the sun, neither moon nor star, nor flash of lightning, nor fire lit on earth. The Self is the light reflected by all. He shining, everything shines after him.

—KATHA UPANISHAD

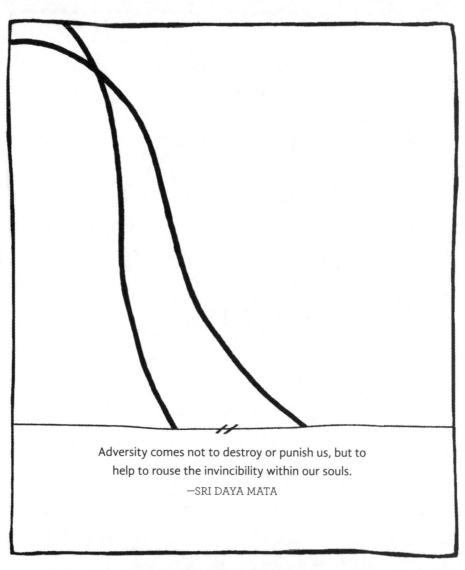

Adversity comes not to destroy or punish us, but to
help to rouse the invincibility within our souls.

—SRI DAYA MATA

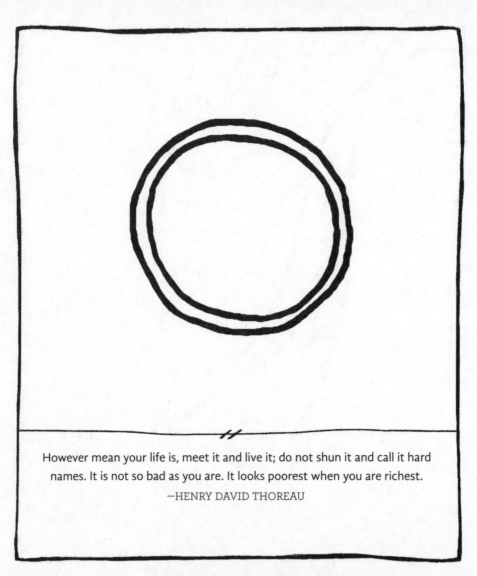

However mean your life is, meet it and live it; do not shun it and call it hard names. It is not so bad as you are. It looks poorest when you are richest.
—HENRY DAVID THOREAU

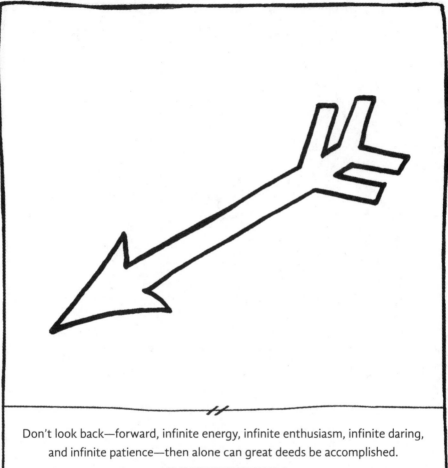

Don't look back—forward, infinite energy, infinite enthusiasm, infinite daring, and infinite patience—then alone can great deeds be accomplished.

—SWAMI VIVEKANANDA

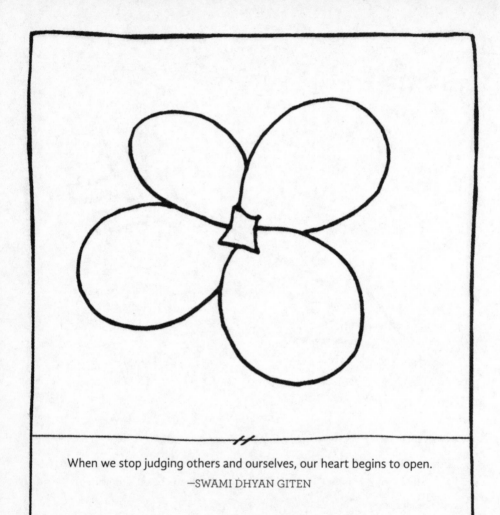

When we stop judging others and ourselves, our heart begins to open.

—SWAMI DHYAN GITEN

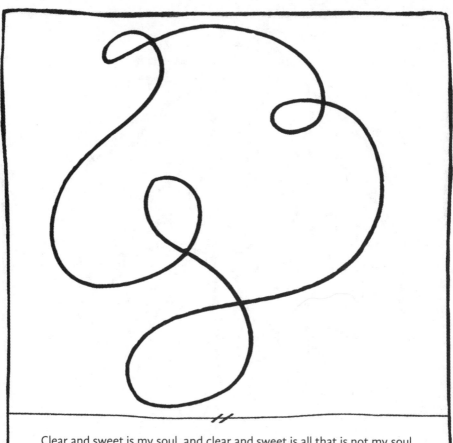

Clear and sweet is my soul, and clear and sweet is all that is not my soul.

—WALT WHITMAN

If you let yourself be blown to and fro, you lose touch with your root.
If you let restlessness move you, you lose touch with who you are.

—LAO TZU

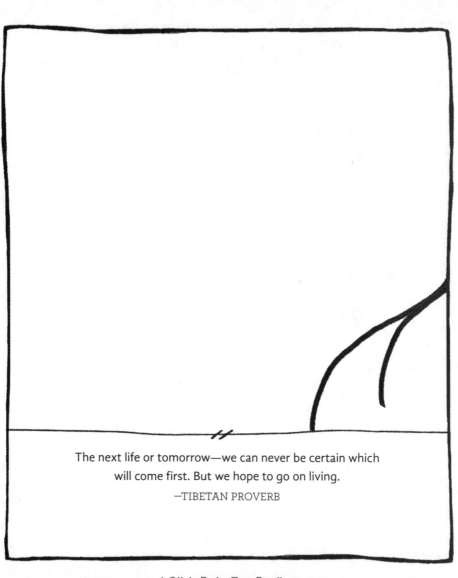

The next life or tomorrow—we can never be certain which
will come first. But we hope to go on living.

—TIBETAN PROVERB

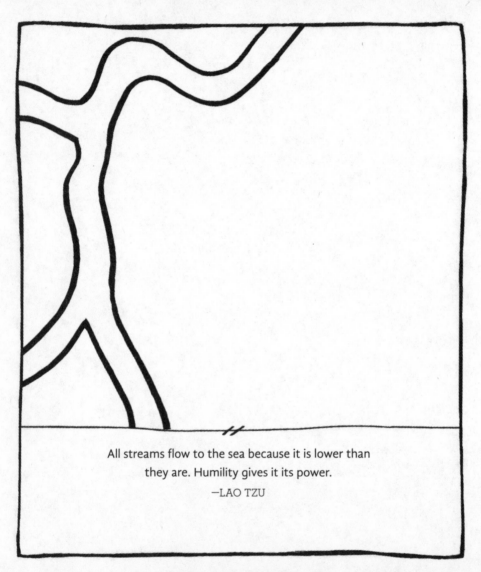

All streams flow to the sea because it is lower than
they are. Humility gives it its power.

—LAO TZU

Take up an idea, devote yourself to it, struggle on
in patience, and the sun will rise for you.

—SWAMI VIVEKANANDA

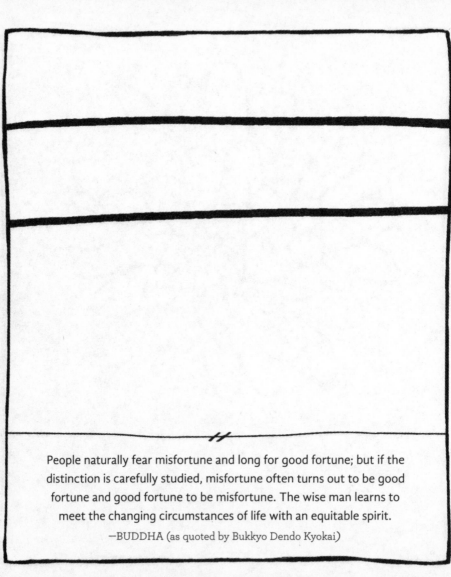

People naturally fear misfortune and long for good fortune; but if the distinction is carefully studied, misfortune often turns out to be good fortune and good fortune to be misfortune. The wise man learns to meet the changing circumstances of life with an equitable spirit.

—BUDDHA (as quoted by Bukkyo Dendo Kyokai)

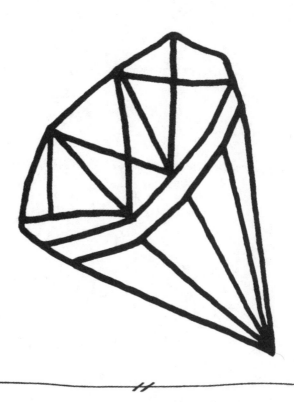

Being wise selfish means taking a broader view and recognizing
that our own long-term individual interest lies in the welfare of
everyone. Being wise selfish means being compassionate.

—THE 14TH DALAI LAMA

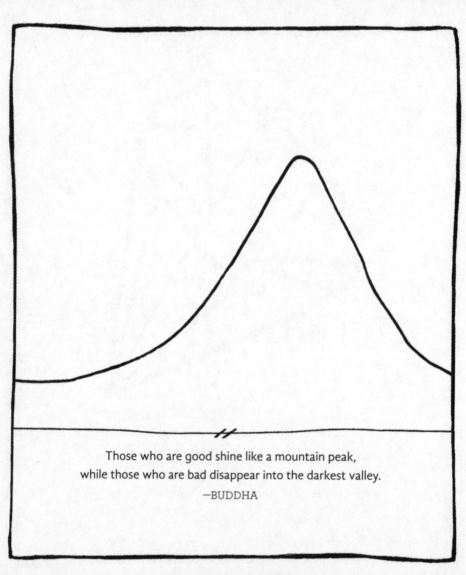

Those who are good shine like a mountain peak,
while those who are bad disappear into the darkest valley.

—BUDDHA

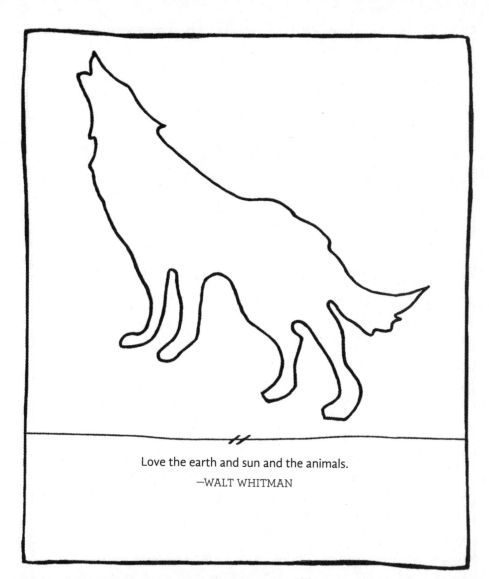

Love the earth and sun and the animals.

—WALT WHITMAN

Ford the fiercest stream of life and overcome desire. Go beyond delusion and opposites.... Attachment will fall away from you and you will know the truth.

—BUDDHA

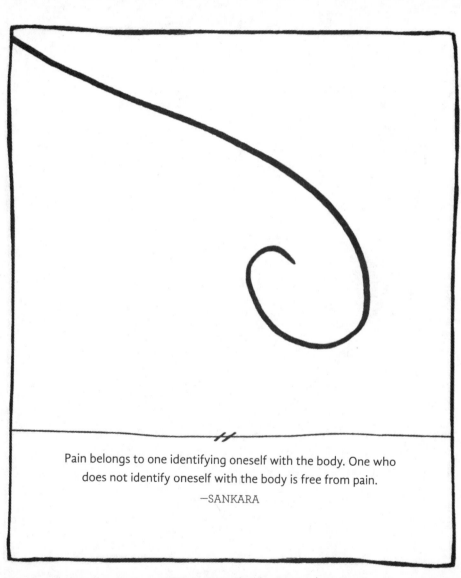

Pain belongs to one identifying oneself with the body. One who does not identify oneself with the body is free from pain.

—SANKARA

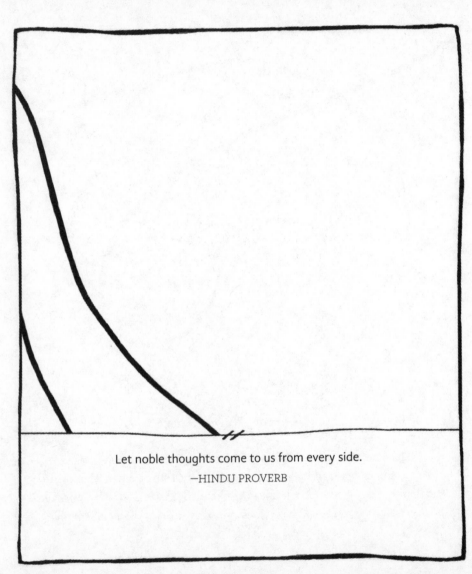

Let noble thoughts come to us from every side.

—HINDU PROVERB

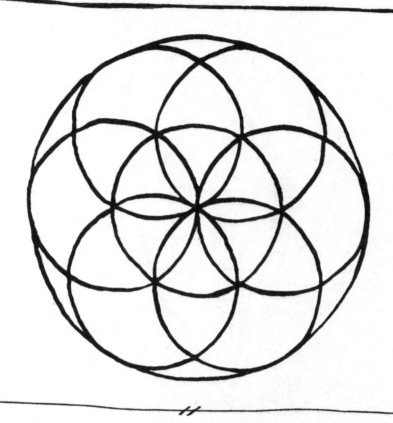

If you have done something meritorious, you experience pleasure and happiness; if wrong things, suffering. A happy or unhappy life is your own creation. Nobody else is responsible. If you remember this, you won't find fault with anybody. You are your own best friend as well as your worst enemy.

—SWAMI SATCHIDANANDA

Seeing into darkness is clarity. Knowing how to yield is strength. Use your own light and return to the source of light. This is called practicing eternity.

—LAO TZU

Trees continue to vegetate, and so do live on beasts and birds; he alone lives whose mind lives not in consequence of taking on a variety of forms. All holy writ is so much burden to him who has no discrimination, ...the mind is so much burden to him who has not acquired self-control.

—HINDU PROVERB

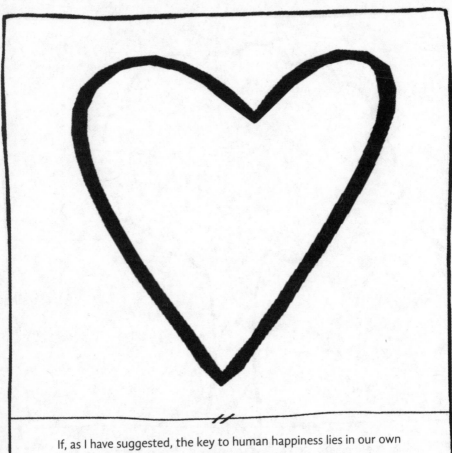

If, as I have suggested, the key to human happiness lies in our own state of mind, so too do the primary obstacles to that happiness.

—THE 14TH DALAI LAMA

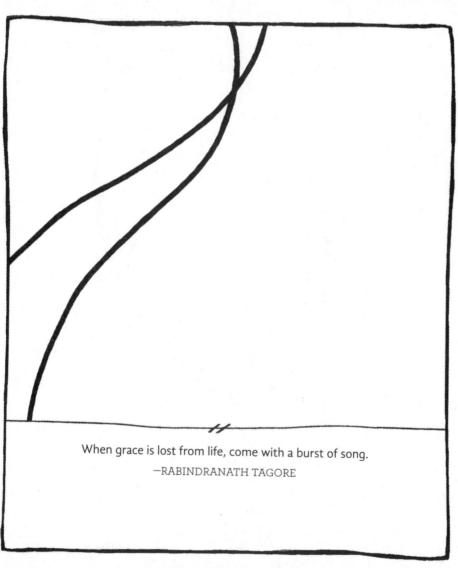

When grace is lost from life, come with a burst of song.

—RABINDRANATH TAGORE

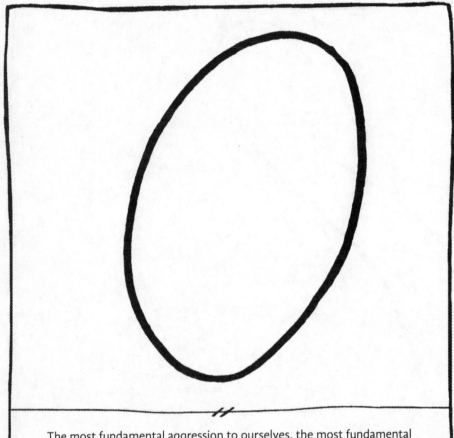

The most fundamental aggression to ourselves, the most fundamental harm we can do to ourselves, is to remain ignorant by not having the courage and the respect to look at ourselves honestly and gently.

—PEMA CHÖDRÖN

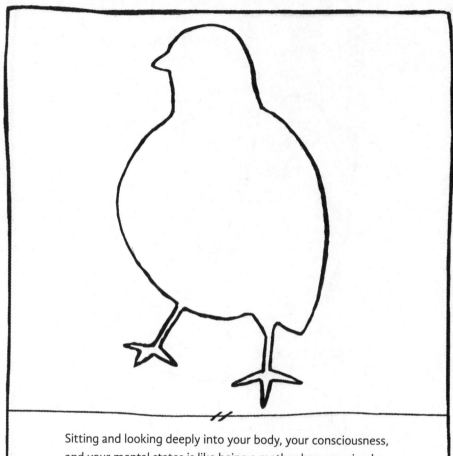

Sitting and looking deeply into your body, your consciousness, and your mental states is like being a mother hen covering her eggs. One day insight will be born like a baby chick.

—THICH NHAT HANH

Men often become what they believe themselves to be. If I believe I cannot do something, it makes me incapable of doing it. But when I believe I can, then I acquire the ability to do it even If I didn't have it in the beginning.

—MAHATMA GANDHI

Look deeply into the nature of suffering to see the
causes of suffering and the way out.

—BUDDHA

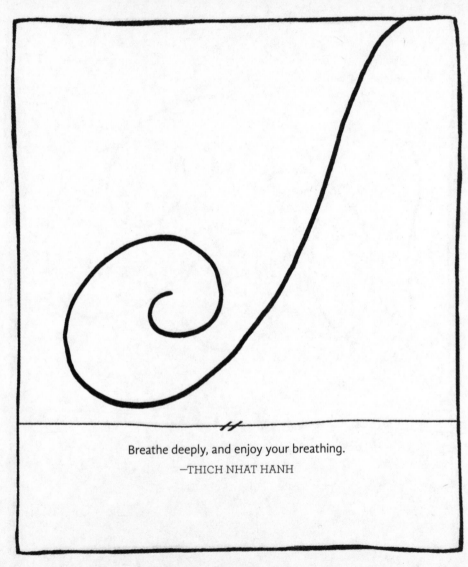

Breathe deeply, and enjoy your breathing.

—THICH NHAT HANH

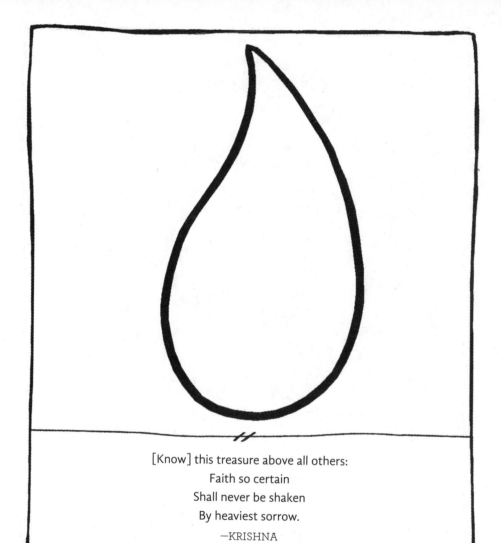

[Know] this treasure above all others:
Faith so certain
Shall never be shaken
By heaviest sorrow.

—KRISHNA

The mind, agitated and unpredictable, needs to fix on a target, in the same way an archer directs an arrow, straight and true.

—BUDDHA

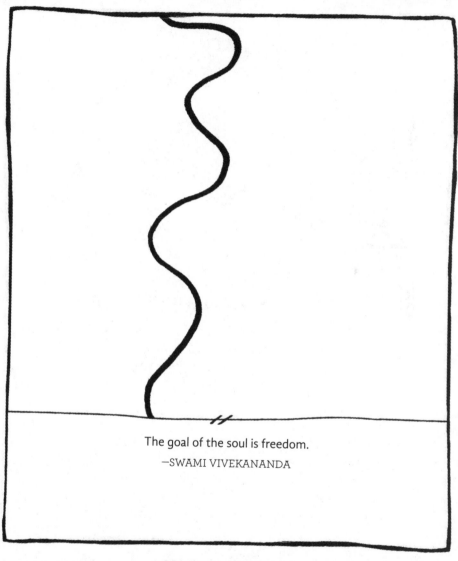

The goal of the soul is freedom.

—SWAMI VIVEKANANDA

We are not going to change the whole world, but we can change ourselves and feel free as birds. We can be serene even in the midst of calamities and, by our serenity, make others more tranquil. Serenity is contagious.... And a smile costs nothing. We should plague everyone with joy.

—SWAMI SATCHIDANANDA (interpreting Patanjali)

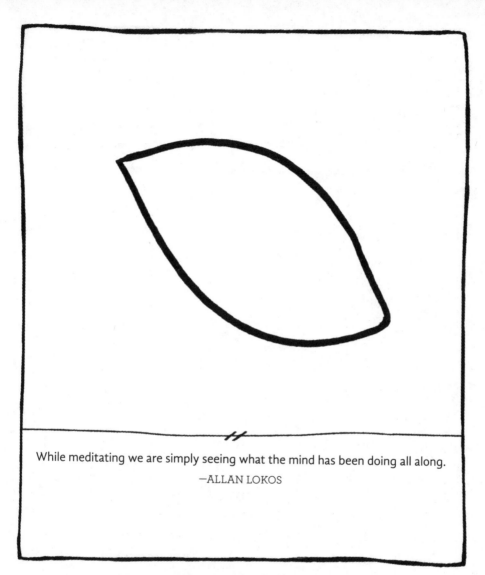

While meditating we are simply seeing what the mind has been doing all along.

—ALLAN LOKOS

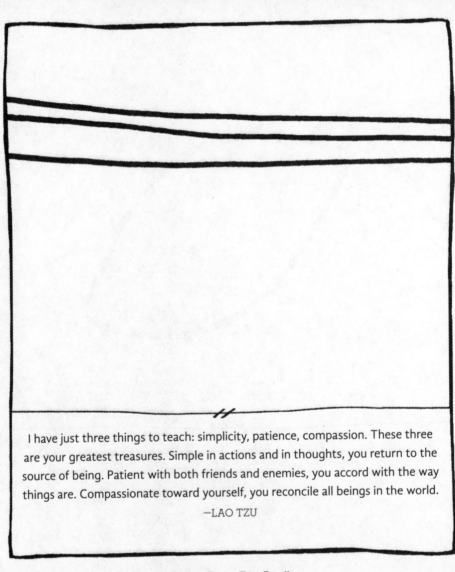

I have just three things to teach: simplicity, patience, compassion. These three are your greatest treasures. Simple in actions and in thoughts, you return to the source of being. Patient with both friends and enemies, you accord with the way things are. Compassionate toward yourself, you reconcile all beings in the world.

—LAO TZU

Each time you look at a tangerine, you can see deeply into it. You can see everything in the universe in one tangerine. When you peel it and smell it, it's wonderful. You can take your time eating a tangerine and be very happy.

—THICH NHAT HANH

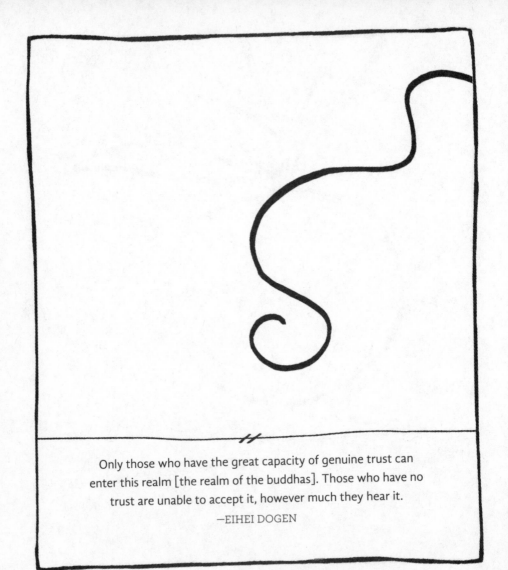

Only those who have the great capacity of genuine trust can
enter this realm [the realm of the buddhas]. Those who have no
trust are unable to accept it, however much they hear it.

—EIHEI DOGEN

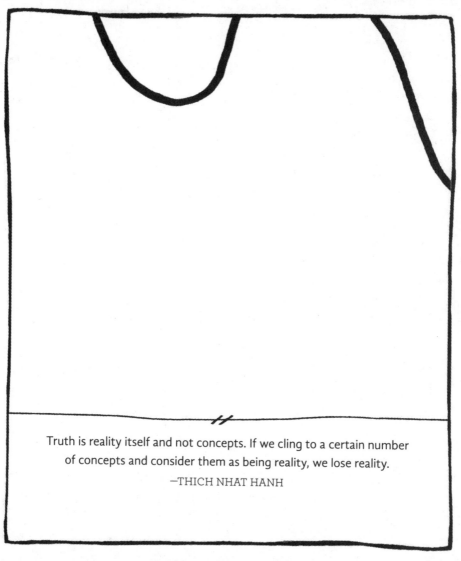

Truth is reality itself and not concepts. If we cling to a certain number of concepts and consider them as being reality, we lose reality.

—THICH NHAT HANH

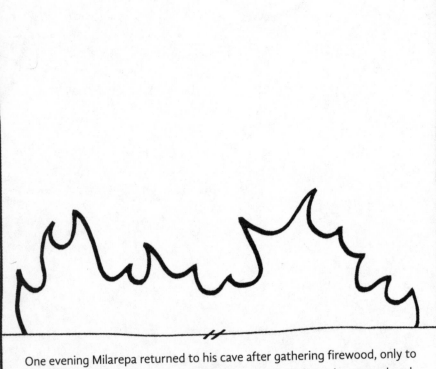

One evening Milarepa returned to his cave after gathering firewood, only to find it filled with demons.... He didn't know what to do, so he surrendered himself even further. He walked over and put himself right into the mouth of the demon and said, "Just eat me up if you want to." Then that demon left too.

—PEMA CHÖDRÖN

Be wary of negativity. Get yourself out of the darkness which waits to trap you.

—BUDDHA

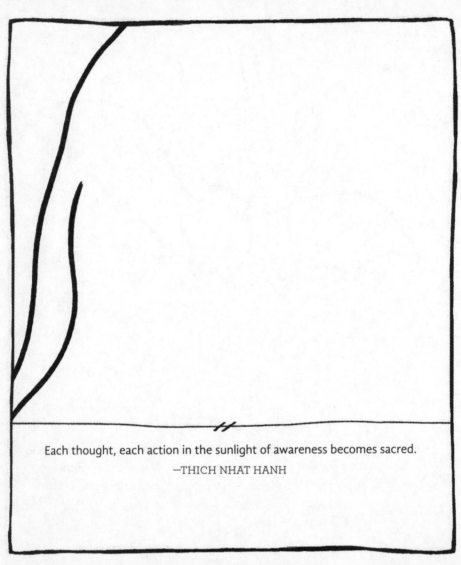

Each thought, each action in the sunlight of awareness becomes sacred.

—THICH NHAT HANH

If a diver is to secure pearls he must descend to the bottom of the sea, braving all dangers of jagged coral and vicious sharks. So man must face the perils of worldly passion if he is to secure the precious pearl of Enlightenment.

—BUDDHA (as quoted by Bukkyo Dendo Kyokai)

From dawn till dusk I sit here before my door, and I know that of a sudden the happy moment will arrive when I shall see. In the meantime I smile and I sing all alone. In the meanwhile the air is filling with the perfume of promise.

—RABINDRANATH TAGORE

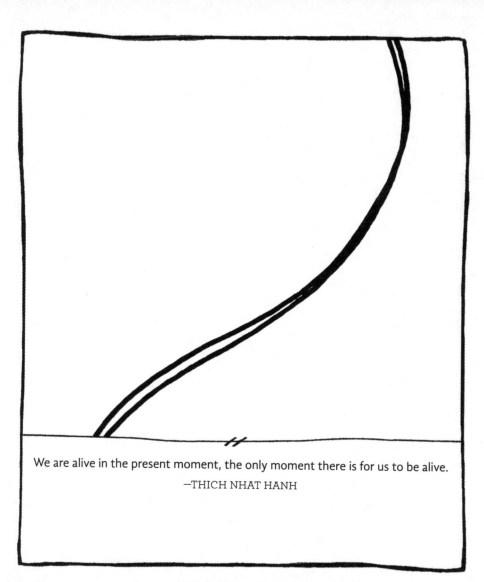

We are alive in the present moment, the only moment there is for us to be alive.

—THICH NHAT HANH

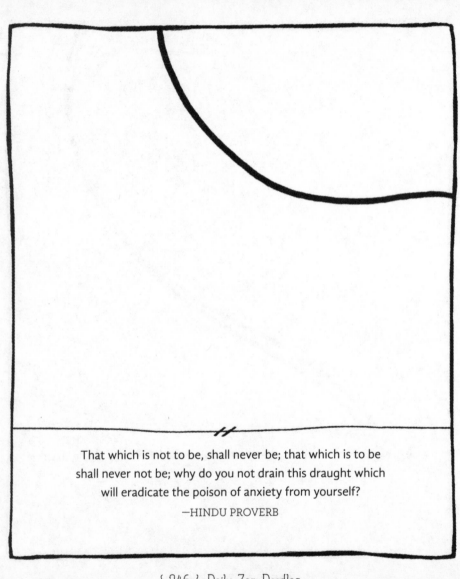

That which is not to be, shall never be; that which is to be
shall never not be; why do you not drain this draught which
will eradicate the poison of anxiety from yourself?

—HINDU PROVERB

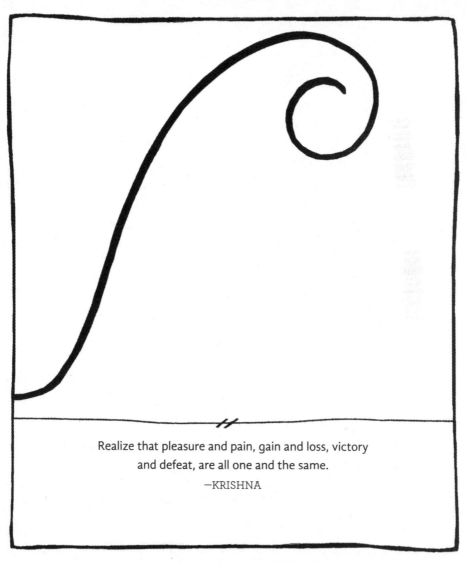

Realize that pleasure and pain, gain and loss, victory
and defeat, are all one and the same.

—KRISHNA

Realize that nothing is permanent and learn from it the emptiness of human life.... The demon of worldly desires is always seeking chances to deceive the mind. If a viper lives in your room and you wish to have a peaceful sleep, you must first chase it out.

—BUDDHA (as quoted by Bukkyo Dendo Kyokai)

You honor yourself by acting with dignity and composure.
—ALLAN LOKOS

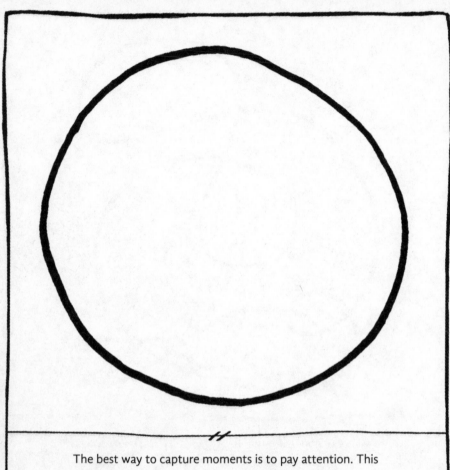

The best way to capture moments is to pay attention. This is how we cultivate mindfulness. Mindfulness means being awake. It means knowing what you are doing.
—JON KABAT-ZINN

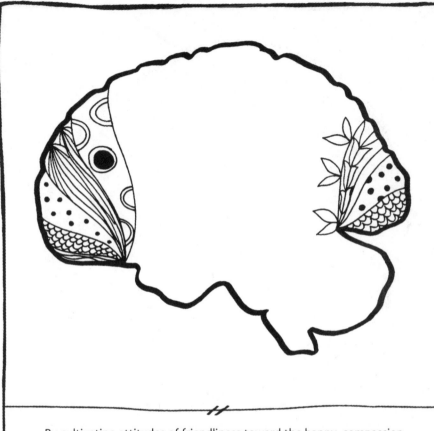

By cultivating attitudes of friendliness toward the happy, compassion for the unhappy, delight in the virtuous, and disregard toward the wicked, the mind-stuff retains its undisturbed calmness.

—PATANJALI

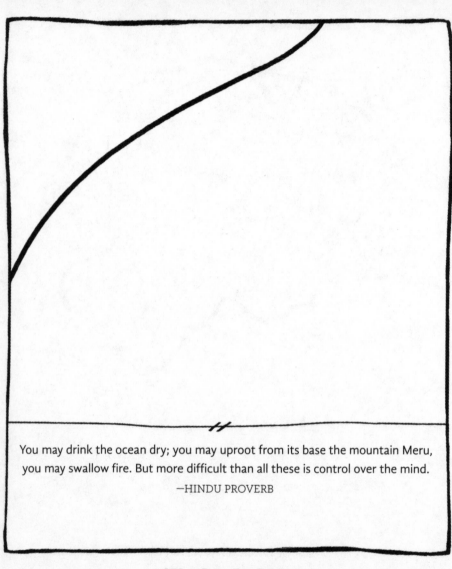

You may drink the ocean dry; you may uproot from its base the mountain Meru, you may swallow fire. But more difficult than all these is control over the mind.

—HINDU PROVERB

The whole of this cosmos is One Self, there is no room for the idea of the body and its like. That is all that is, all bliss, whatever else you see is all thought.

—HINDU PROVERB

Live in accord with nature, and if you are happy there will be
no wanting in your life. This will give you concentration.

—BUDDHA

For eternally and always there is only now, one and the same
now; the present is the only thing that has no end.
—ERWIN SCHRÖDINGER

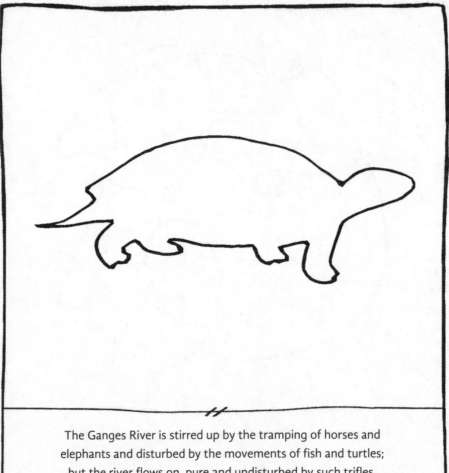

The Ganges River is stirred up by the tramping of horses and elephants and disturbed by the movements of fish and turtles; but the river flows on, pure and undisturbed by such trifles.

—BUDDHA (as quoted by Bukkyo Dendo Kyokai)

If you do not pour water on your plant, what will happen? It will slowly
wither and die. Our habits will also slowly wither and die away if we
do not give them an opportunity to manifest. You need not fight to
stop a habit. Just don't give it an opportunity to repeat itself.

—SWAMI SATCHIDANANDA

Let peace...enable you to gather your scattered mind into the mindfulness of Calm Abiding, and awaken in you...Clear Seeing. And you will find all your negativity disarmed, your aggression dissolved, and your confusion evaporating slowly, like mist into...stainless sky of your absolute nature.

—SOGYAL RINPOCHE

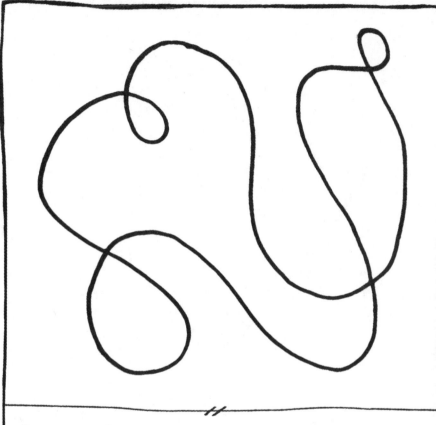

[A human being] experiences himself, his thoughts and feelings as something separated from the rest.... This delusion is a kind of prison for us.... Our task must be to free ourselves from this prison by widening our circle of compassion to embrace all living creatures and the whole of nature in its beauty.

—ALBERT EINSTEIN

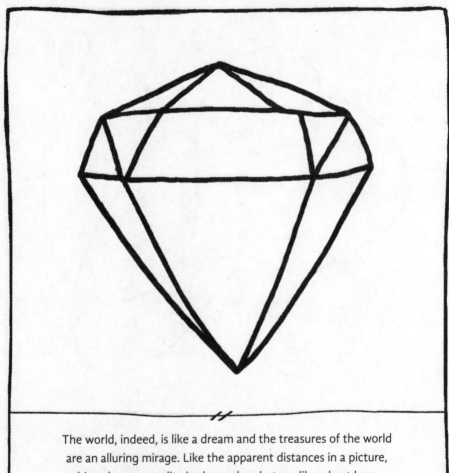

The world, indeed, is like a dream and the treasures of the world are an alluring mirage. Like the apparent distances in a picture, things have no reality in themselves but are like a heat haze.

—BUDDHA (as quoted by Bukkyo Dendo Kyokai)

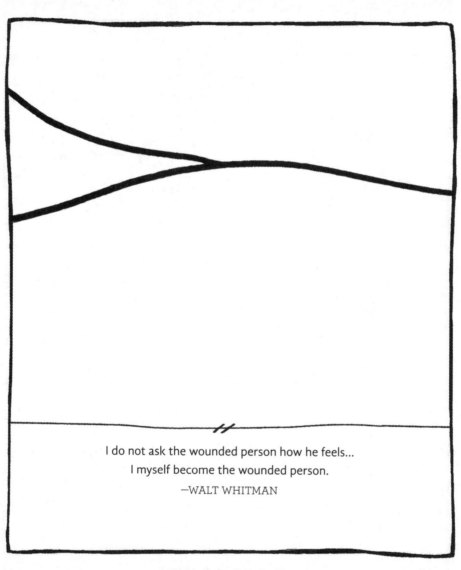

I do not ask the wounded person how he feels...
I myself become the wounded person.

—WALT WHITMAN

To be here, now, and to enjoy the present moment is our most important task.

—THICH NHAT HANH

Kindness is the light that dissolves all walls between souls, families, and nations.

—PARAMAHANSA YOGANANDA

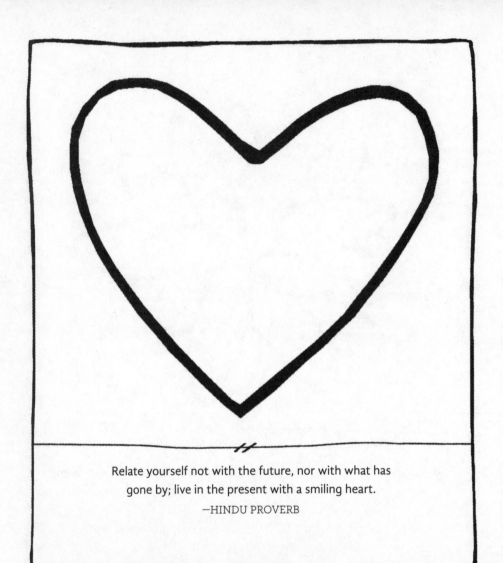

Relate yourself not with the future, nor with what has
gone by; live in the present with a smiling heart.

—HINDU PROVERB

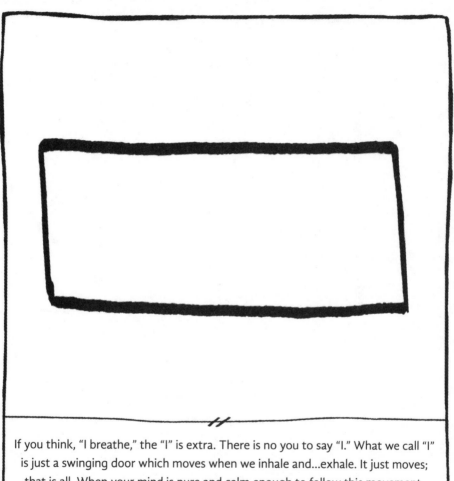

If you think, "I breathe," the "I" is extra. There is no you to say "I." What we call "I" is just a swinging door which moves when we inhale and...exhale. It just moves; that is all. When your mind is pure and calm enough to follow this movement, there is nothing: no "I," no world, no mind nor body; just a swinging door.

—SHUNRYU SUZUKI

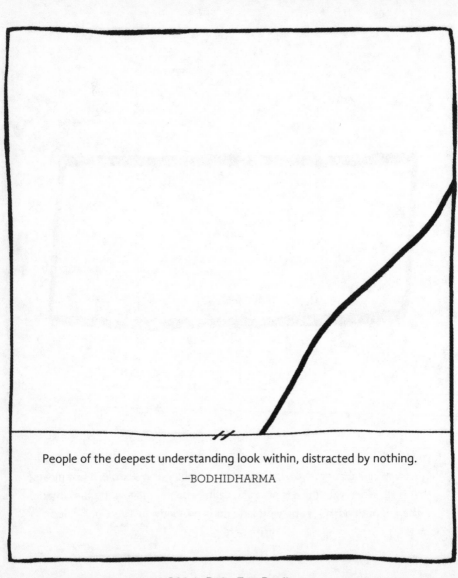

People of the deepest understanding look within, distracted by nothing.

—BODHIDHARMA

As a farmer irrigates the fields, as an archer guides the arrows, and as a carpenter shapes the wood, so the true disciple molds his or her mind.

—BUDDHA

When we come to nonattachment, then we can understand the marvelous mystery of the universe: how it is intense activity and at the same time intense peace, how it is work every moment and rest every moment.

—SWAMI VIVEKANANDA

A great nation is like a great man: When he makes a mistake, he realizes it. Having realized it, he admits it. Having admitted it, he corrects it. He considers those who point out his faults as his most benevolent teachers. He thinks of his enemy as the shadow that he himself casts.

—LAO TZU

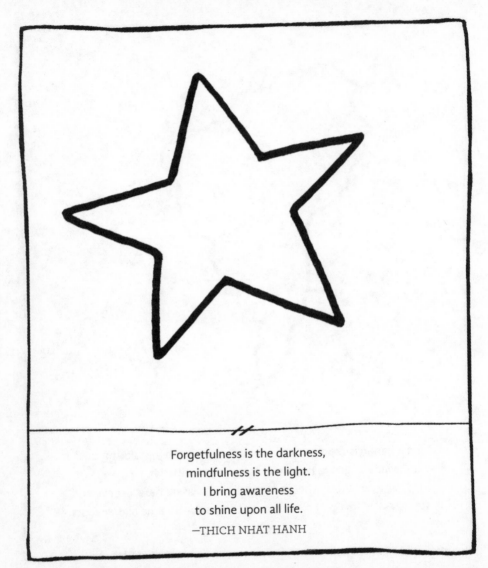

Forgetfulness is the darkness,
mindfulness is the light.
I bring awareness
to shine upon all life.

—THICH NHAT HANH

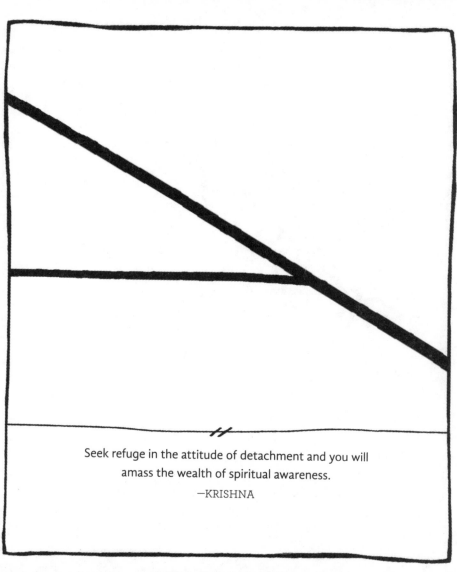

Seek refuge in the attitude of detachment and you will
amass the wealth of spiritual awareness.

—KRISHNA

I went to the woods because I wished to live deliberately, to front only
the essential facts of life, and see if I could not learn what it had to
teach, and not, when I came to die, discover that I had not lived.
—HENRY DAVID THOREAU

These roses under my window make no reference to former roses or to better ones; they are for what they are; they exist with God to-day. There is no time to them. There is simply the rose; it is perfect in every moment of its existence.

—RALPH WALDO EMERSON

Ego—the less there is of it, the nearer I am to that which I really am; the Universal Spirit. The less I think of my own individual mind, the nearer I am to the Universal Mind. The less I think of my own soul, the nearer I am to the Universal Soul.

—SWAMI VIVEKANANDA

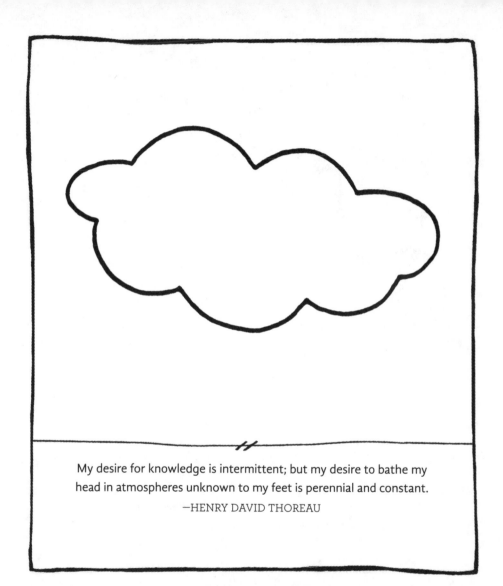

My desire for knowledge is intermittent; but my desire to bathe my
head in atmospheres unknown to my feet is perennial and constant.

—HENRY DAVID THOREAU

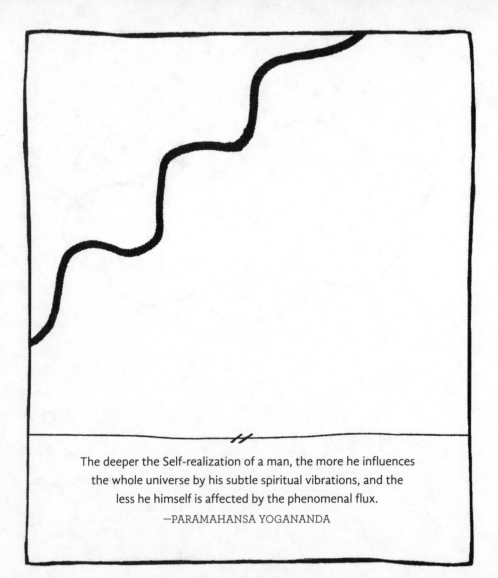

The deeper the Self-realization of a man, the more he influences
the whole universe by his subtle spiritual vibrations, and the
less he himself is affected by the phenomenal flux.

—PARAMAHANSA YOGANANDA

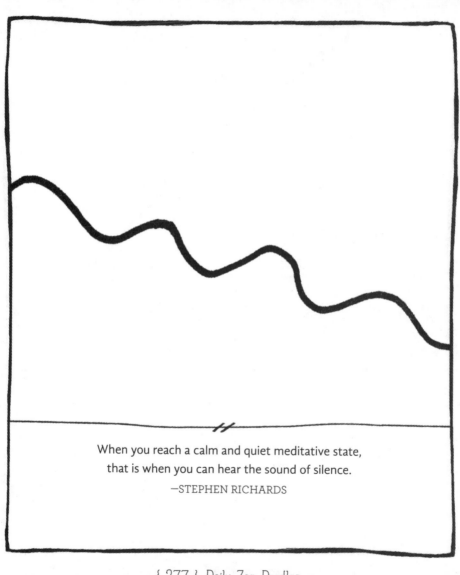

When you reach a calm and quiet meditative state,
that is when you can hear the sound of silence.

—STEPHEN RICHARDS

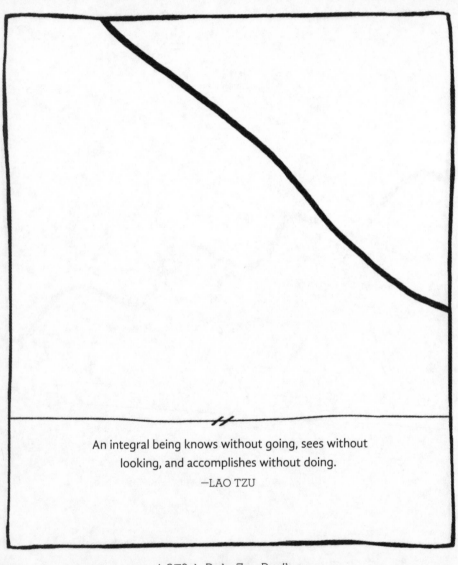

An integral being knows without going, sees without
looking, and accomplishes without doing.

—LAO TZU

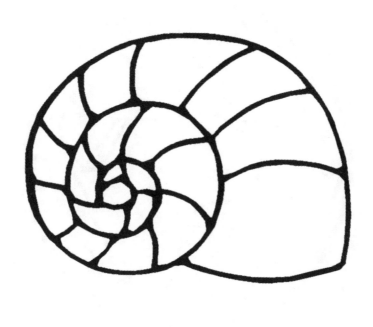

It is simply the mind clouded over by impure desires, and impervious to wisdom, that obstinately persists in thinking of "me" and "mine."

—BUDDHA (as quoted by Bukkyo Dendo Kyokai)

Be content with what you have; rejoice in the way things are.
When you realize there is nothing lacking, the whole world belongs to you.

—LAO TZU

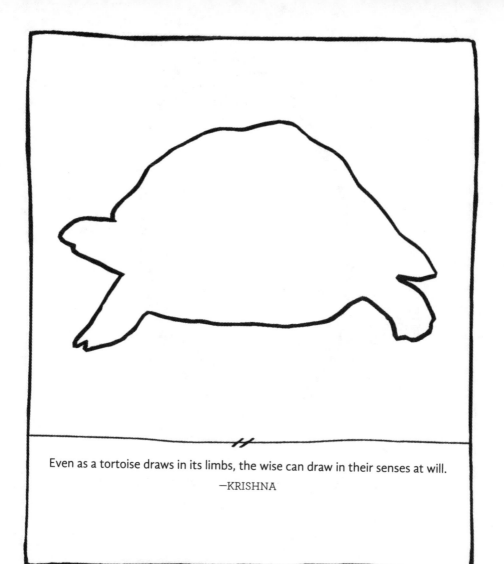

Even as a tortoise draws in its limbs, the wise can draw in their senses at will.

—KRISHNA

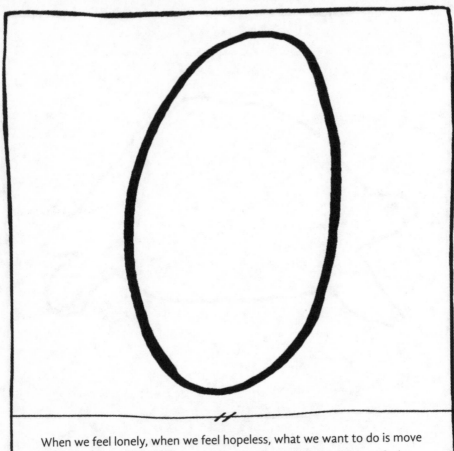

When we feel lonely, when we feel hopeless, what we want to do is move to the right or the left. We don't want to sit and feel what we feel.

—PEMA CHÖDRÖN

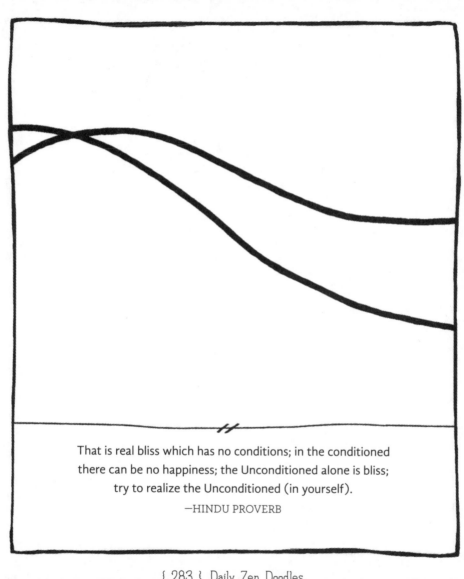

That is real bliss which has no conditions; in the conditioned
there can be no happiness; the Unconditioned alone is bliss;
try to realize the Unconditioned (in yourself).

—HINDU PROVERB

The power is with the silent ones, who only live and love and then withdraw their personality. They never say "me" and "mine"; they are only blessed in being instruments.

—SWAMI VIVEKANANDA

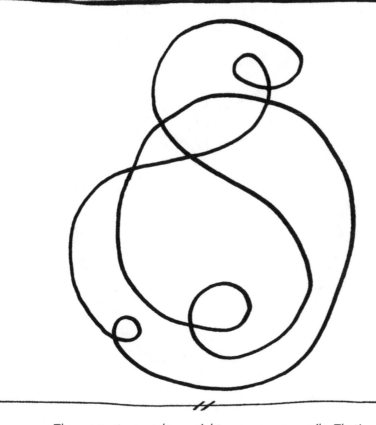

The moment you wake up, right away, you can smile. That's a smile of enlightenment. You are aware that a new day is beginning, that life is offering you twenty-four brand-new hours to live, and that that's the most precious of gifts.

—THICH NHAT HANH

When we are mindful, touching deeply the present moment, we can see and listen deeply, and the fruits are always understanding, acceptance, love.

—THICH NHAT HANH

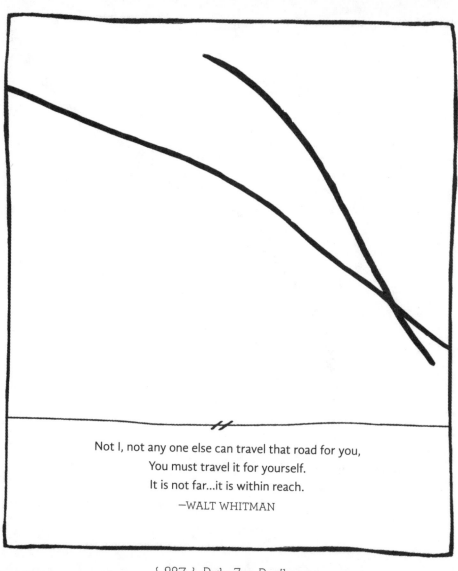

Not I, not any one else can travel that road for you,
You must travel it for yourself.
It is not far...it is within reach.

—WALT WHITMAN

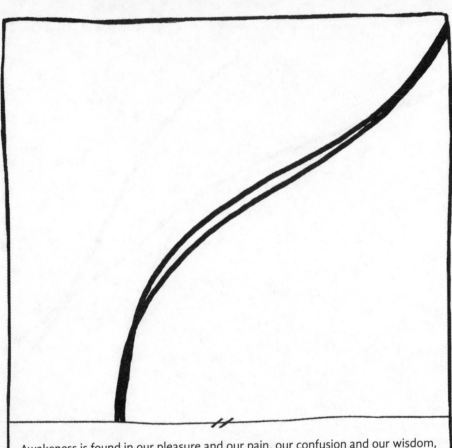

Awakeness is found in our pleasure and our pain, our confusion and our wisdom, available in each moment of our weird, unfathomable, ordinary everyday lives.

—PEMA CHÖDRÖN

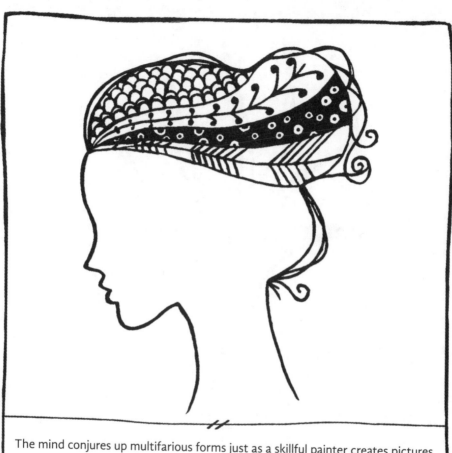

The mind conjures up multifarious forms just as a skillful painter creates pictures of various worlds. There is nothing in the world that is not mind-created.

—BUDDHA (as quoted by Bukkyo Dendo Kyokai)

When St. Francis looked deeply at an almond tree in winter and asked it to
speak to him about God, the tree was instantly covered with blossoms.

—THICH NHAT HANH

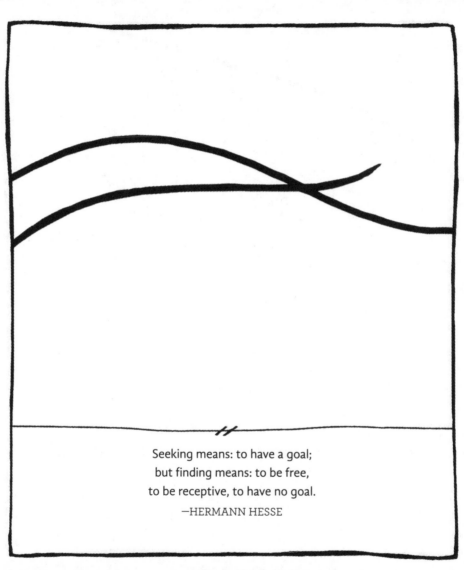

Seeking means: to have a goal;
but finding means: to be free,
to be receptive, to have no goal.

—HERMANN HESSE

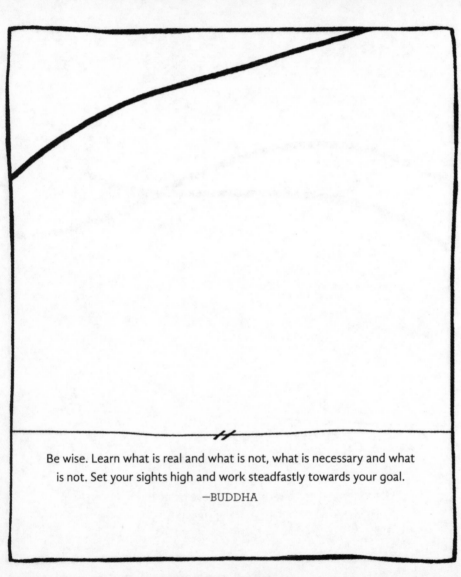

Be wise. Learn what is real and what is not, what is necessary and what is not. Set your sights high and work steadfastly towards your goal.

—BUDDHA

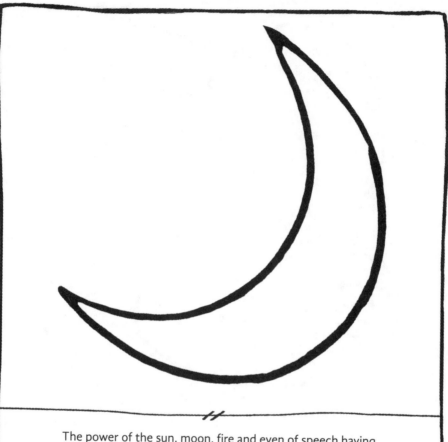

The power of the sun, moon, fire and even of speech having exhausted itself; the senses being all extinguished. That which stands self-illumined, beyond all relations, sending forth this universe of ideas, and all thought, is shown to be the Inner Self of all.

—HINDU PROVERB

If we scan our inner self, we will find a hunger, a yearning, a need, for a kind of love that will consume us with total fulfillment; and for a complete security that nothing in this world can give—neither money nor health, nor any amount of intellectual understanding.

—SRI DAYA MATA

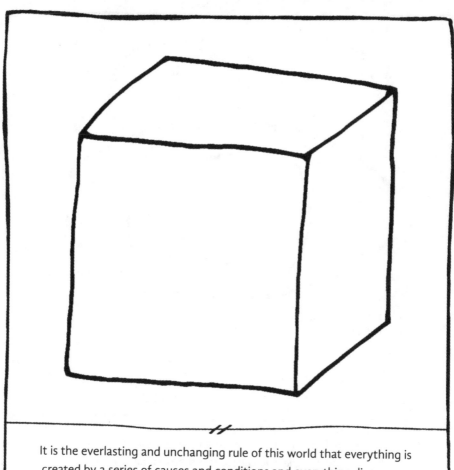

It is the everlasting and unchanging rule of this world that everything is
created by a series of causes and conditions and everything disappears
by the same rule; everything changes, nothing remains constant.

—BUDDHA (as quoted by Bukkyo Dendo Kyokai)

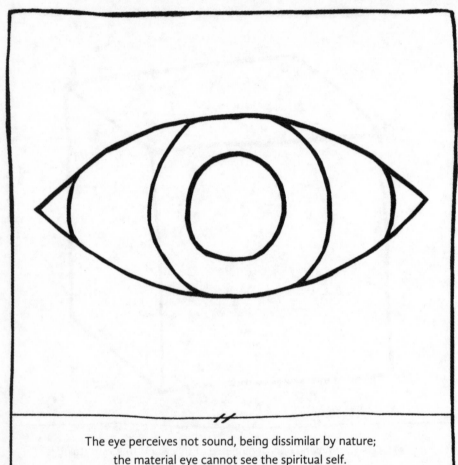

The eye perceives not sound, being dissimilar by nature;
the material eye cannot see the spiritual self.

—HINDU PROVERB

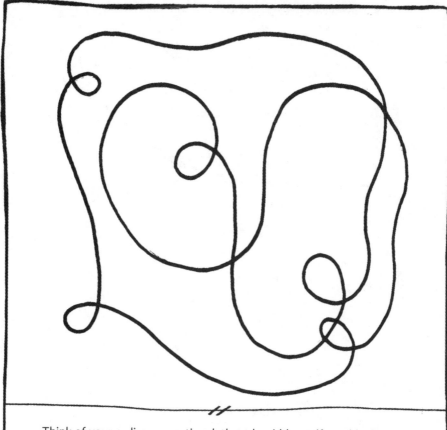

Think of your ordinary emotional, thought-ridden self as a block of ice
or a slab of butter left out in the sun. If you are feeling hard and cold,
let this aggression melt away in the sunlight of your meditation.

—SOGYAL RINPOCHE

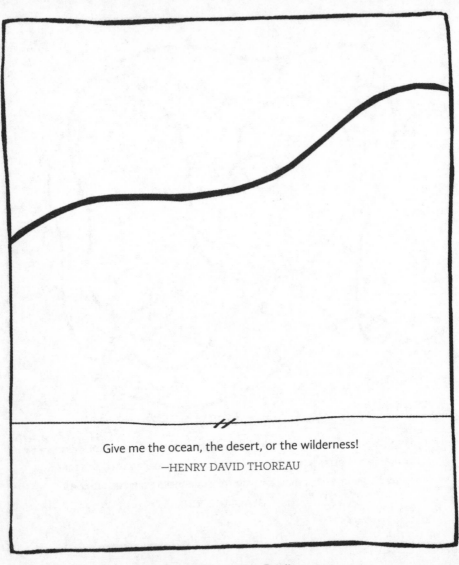

Give me the ocean, the desert, or the wilderness!
—HENRY DAVID THOREAU

Dig up and destroy the root of desire if you do not want temptation to control your life. For a tree which has been cut down will grow again if given the chance, and so will desire if the roots are not destroyed.

—BUDDHA

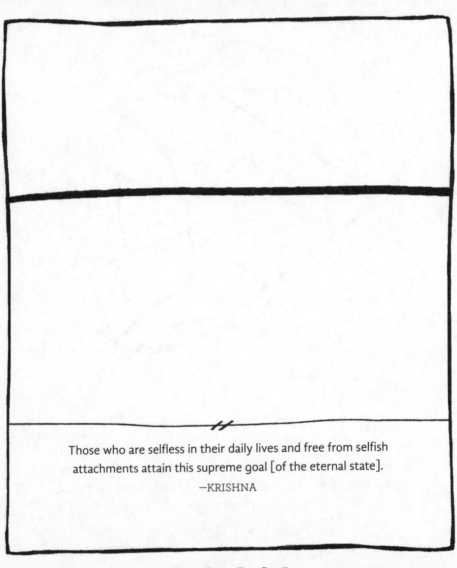

Those who are selfless in their daily lives and free from selfish
attachments attain this supreme goal [of the eternal state].

—KRISHNA

The young warrior said, "How can I defeat you?" Fear replied, "My weapons are that I talk fast, and I get very close to your face. Then you get completely unnerved, and you do whatever I say. If you don't do what I tell you, I have no power.... In that way, the student warrior learned how to defeat fear.

—PEMA CHÖDRÖN

If the mind falls asleep, awaken it. Then if it starts wandering, make it quiet. If you reach the state where there is neither sleep nor movement of mind, stay still in that, the natural (real) state.

—RAMANA MAHARSHI

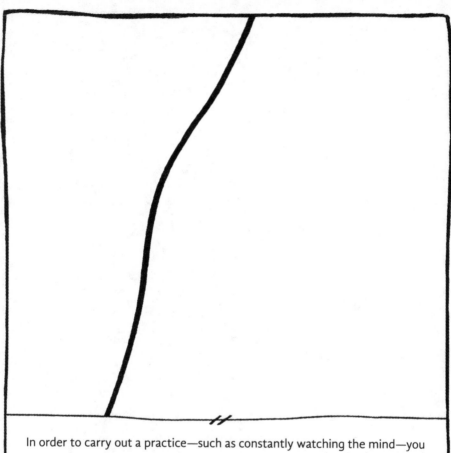

In order to carry out a practice—such as constantly watching the mind—you should form a determination, make a pledge, right when you wake up: "Now, for the rest of this day, I will put into practice what I believe just as much as I can."

—THE 14TH DALAI LAMA

To look at everything always as though you were seeing it either for the first or last time: Thus is your time on earth filled with glory.

—BETTY SMITH

All that is harsh and dissonant in my life melts into one sweet harmony—and my adoration spreads wings like a glad bird on its flight across the sea.

—RABINDRANATH TAGORE

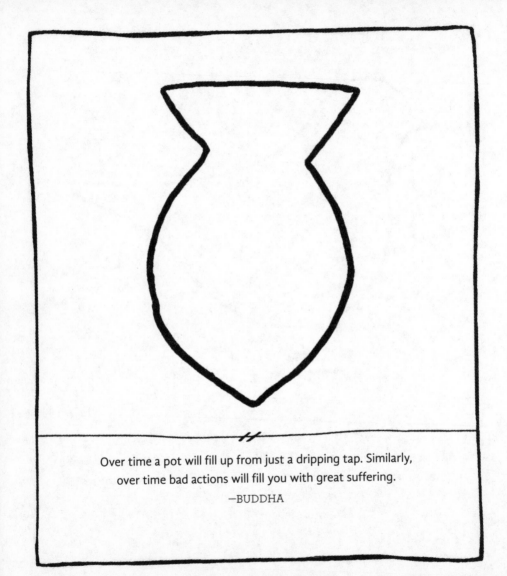

Over time a pot will fill up from just a dripping tap. Similarly,
over time bad actions will fill you with great suffering.

—BUDDHA

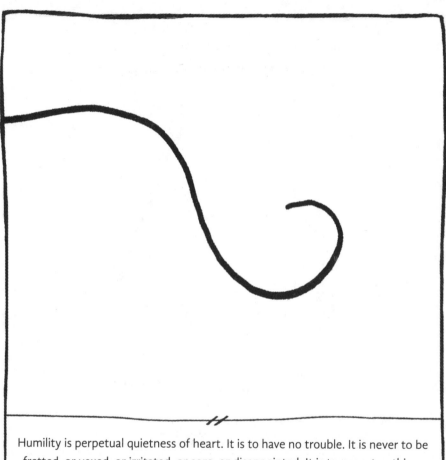

Humility is perpetual quietness of heart. It is to have no trouble. It is never to be fretted, or vexed, or irritated, or sore, or disappointed. It is to expect nothing, to wonder at nothing that is done to me, to feel nothing done against me. It is to be at rest when nobody praises me, and when I am blamed and despised.

—CANON T. T. CARTER (as quoted by Sri Daya Mata)

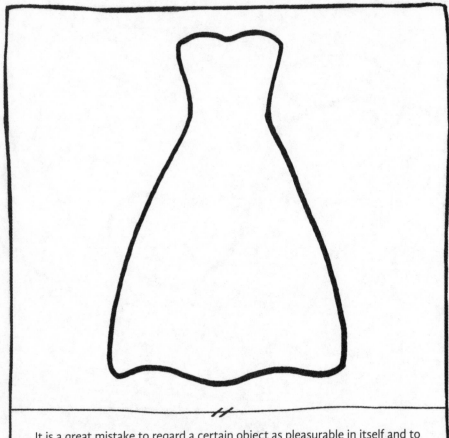

It is a great mistake to regard a certain object as pleasurable in itself and to store the idea of it in the mind in the hope of fulfilling a want by its actual presence in the future. If objects were pleasurable in themselves, then the same dress or food would always please everyone, which is not the case.

—PARAMAHANSA YOGANANDA

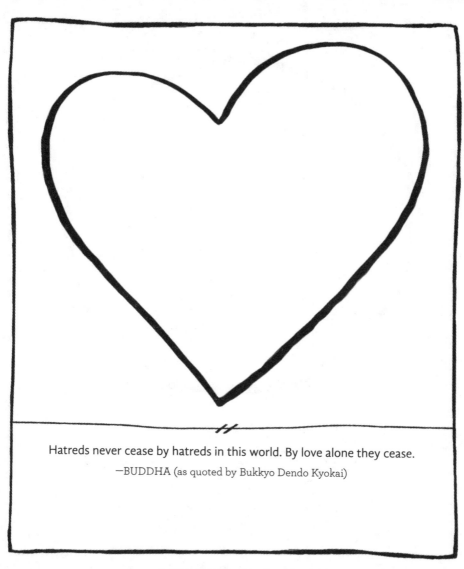

Hatreds never cease by hatreds in this world. By love alone they cease.

—BUDDHA (as quoted by Bukkyo Dendo Kyokai)

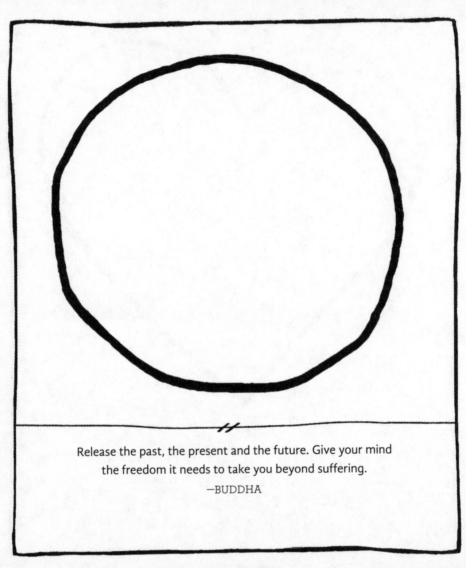

Release the past, the present and the future. Give your mind
the freedom it needs to take you beyond suffering.

—BUDDHA

I shall ever try to drive all evils away from my heart and keep my love in flower.

—RABINDRANATH TAGORE

Every day we are engaged in a miracle which we don't even recognize: a blue sky, white clouds, green leaves, the black, curious eyes of a child—our own two eyes. All is a miracle.

—THICH NHAT HANH

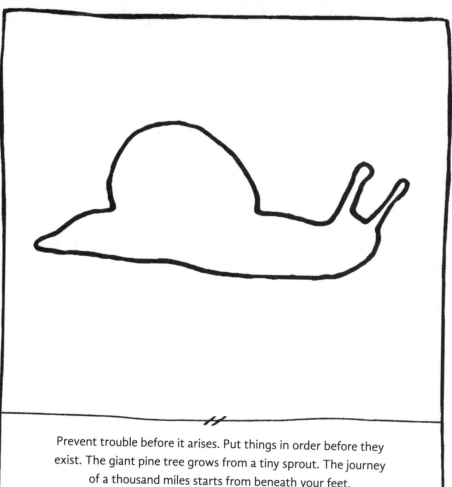

Prevent trouble before it arises. Put things in order before they exist. The giant pine tree grows from a tiny sprout. The journey of a thousand miles starts from beneath your feet.

—LAO TZU

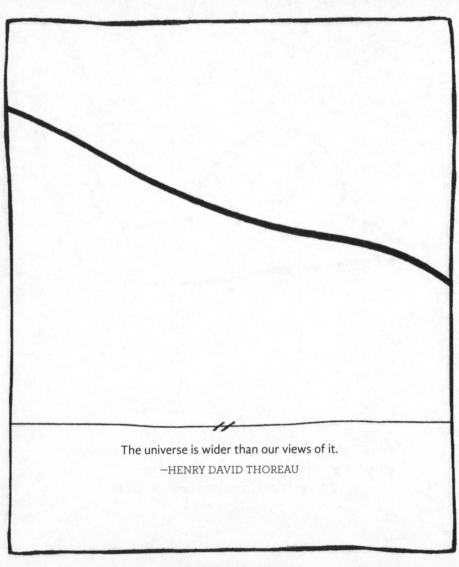

The universe is wider than our views of it.

—HENRY DAVID THOREAU

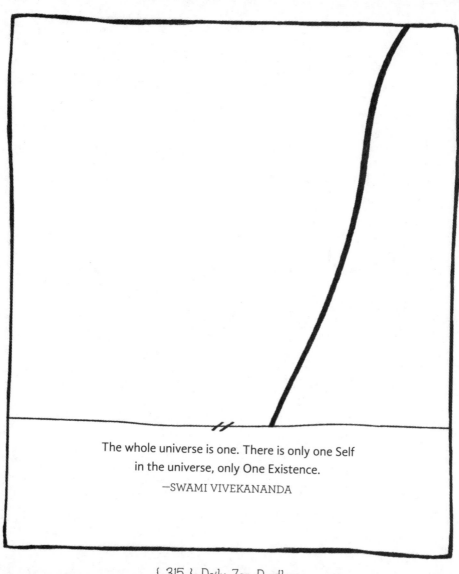

The whole universe is one. There is only one Self
in the universe, only One Existence.
—SWAMI VIVEKANANDA

In dwelling, live close to the ground. In thinking, keep to the simple.
In conflict, be fair and generous. In governing, don't try to control.
In work, do what you enjoy. In family life, be completely present.

—LAO TZU

Everything is sorrow for the wise.

—PATANJALI

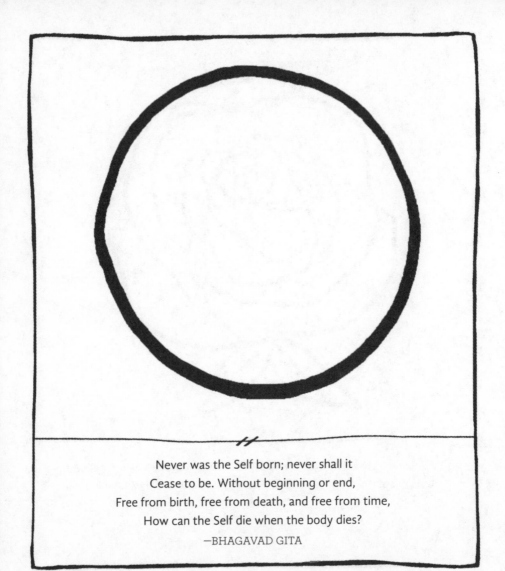

Never was the Self born; never shall it
Cease to be. Without beginning or end,
Free from birth, free from death, and free from time,
How can the Self die when the body dies?

—BHAGAVAD GITA

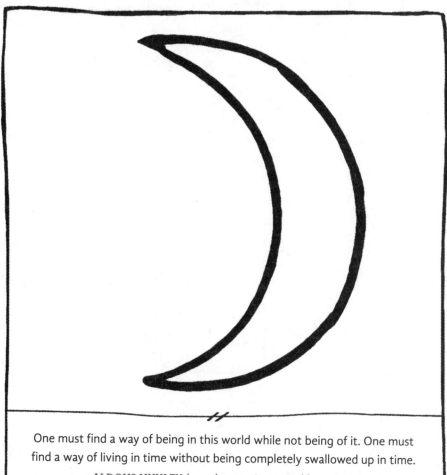

One must find a way of being in this world while not being of it. One must find a way of living in time without being completely swallowed up in time.

—ALDOUS HUXLEY (paraphrasing Swami Prabhavananda)

The spirit is the cause of all our thoughts and body-action, and everything,
but it is untouched by good or evil, pleasure or pain, heat or cold, and
all the dualism of nature, although it lends its light to everything.
—SWAMI VIVEKANANDA

Foolish people dread misfortune and strive after good
fortune, but those who seek Enlightenment must transcend
both of them and be free of worldly attachments.

—BUDDHA (as quoted by Bukkyo Dendo Kyokai)

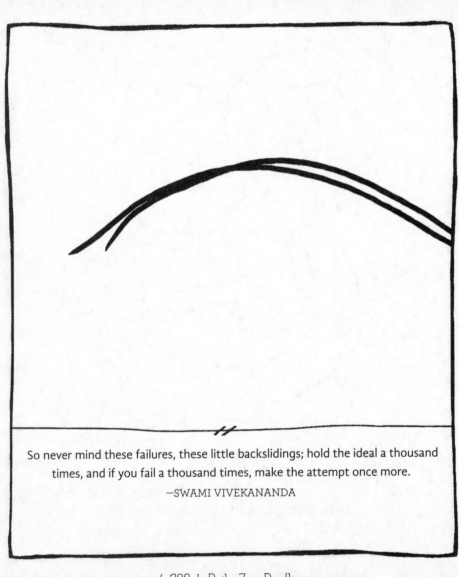

So never mind these failures, these little backslidings; hold the ideal a thousand times, and if you fail a thousand times, make the attempt once more.

—SWAMI VIVEKANANDA

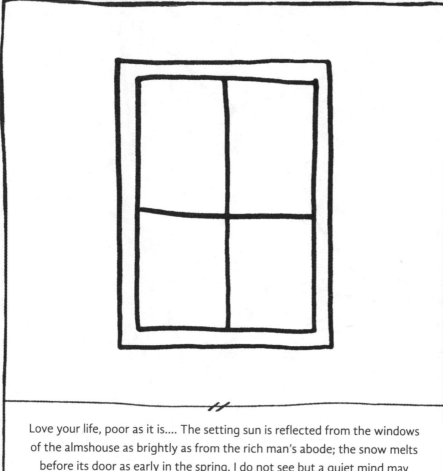

Love your life, poor as it is.... The setting sun is reflected from the windows of the almshouse as brightly as from the rich man's abode; the snow melts before its door as early in the spring. I do not see but a quiet mind may live as contentedly there, and have as cheering thoughts, as in a palace.

—HENRY DAVID THOREAU

It is only important to love the world, not to despise it, not for us to hate each other, but to be able to regard the world and ourselves and all beings with love, admiration and respect.

—HERMANN HESSE

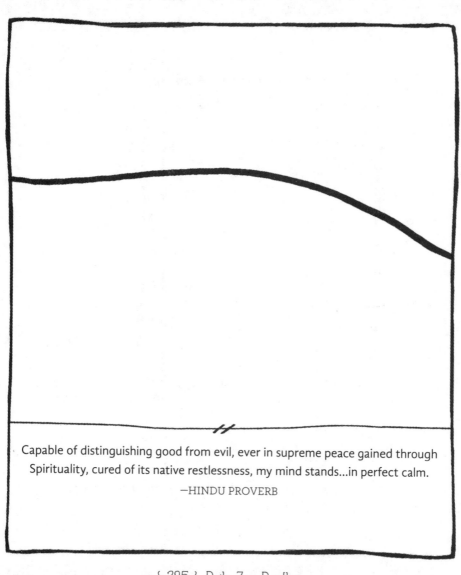

Capable of distinguishing good from evil, ever in supreme peace gained through
Spirituality, cured of its native restlessness, my mind stands...in perfect calm.

—HINDU PROVERB

Think clearly and learn well. Have control over yourself
and speak kindly to all. This is a true blessing.

—BUDDHA

I don't want to be at home only with my friends, I
want to be at home with my enemies, too.

—MAHATMA GANDHI

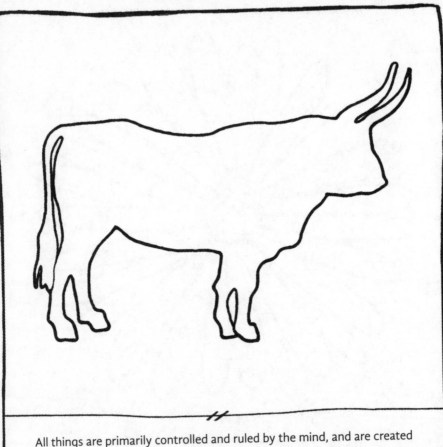

All things are primarily controlled and ruled by the mind, and are created up by the mind. As the wheels follow the ox that draws the cart, so does suffering follow the person who speaks and acts with an impure mind.

—BUDDHA (as quoted by Bukkyo Dendo Kyokai)

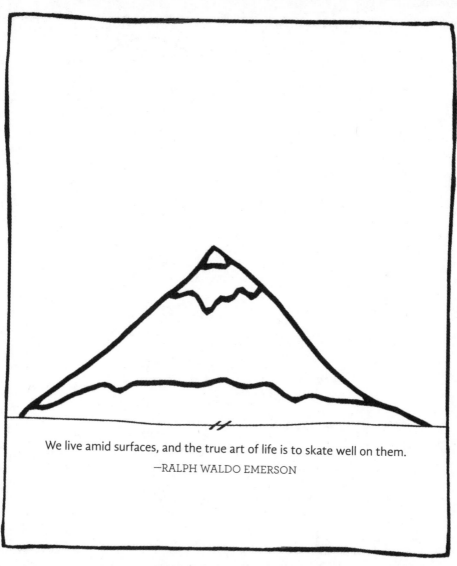

We live amid surfaces, and the true art of life is to skate well on them.

—RALPH WALDO EMERSON

If good things come, welcome; if they go away, welcome, let them go.
Blessed are they when they come, and blessed are they when they go.

—SWAMI VIVEKANANDA

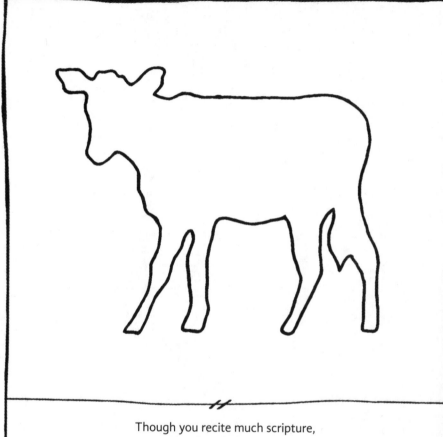

Though you recite much scripture,
If you are unaware and do not act according
You are like a cowherd counting others' cattle,
Not a sharer in the wanderer's life.

—BUDDHA

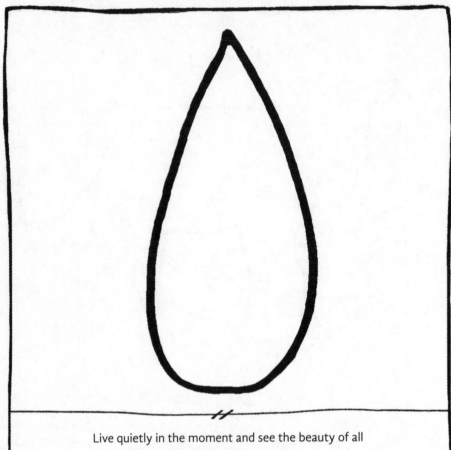

Live quietly in the moment and see the beauty of all
before you. The future will take care of itself.

—PARAMAHANSA YOGANANDA

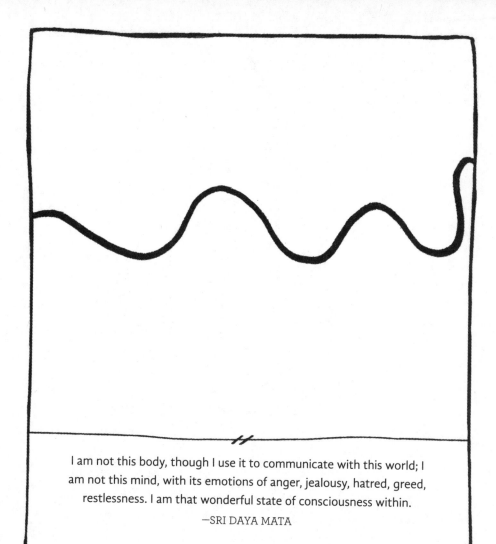

I am not this body, though I use it to communicate with this world; I am not this mind, with its emotions of anger, jealousy, hatred, greed, restlessness. I am that wonderful state of consciousness within.

—SRI DAYA MATA

Truth alone conquers, not falsehood, the divine path stands upheld by Truth; sages with desires put out by satiety pass over it to the great treasure of Truth. It (the Truth) is all-embracing yet unthinkable, all light, minutest of the minute yet ever manifest.

—HINDU PROVERB

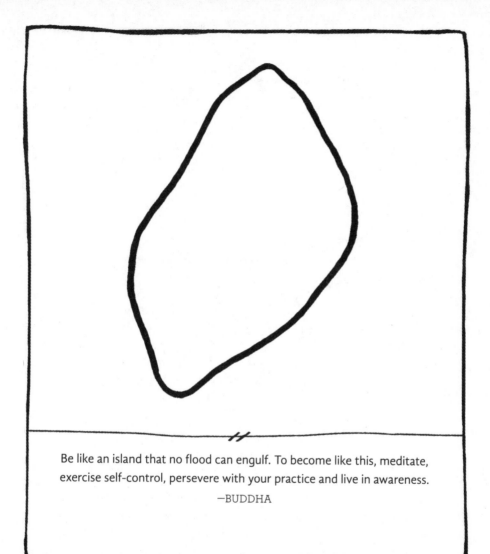

Be like an island that no flood can engulf. To become like this, meditate, exercise self-control, persevere with your practice and live in awareness.

—BUDDHA

Buddha-nature exists in everyone no matter how deeply it may be covered over by greed, anger and foolishness, or buried by his own deeds and retribution. Buddha-nature can not be lost or destroyed; and when all defilements are removed, sooner or later it will reappear.

—BUDDHA (as quoted by Bukkyo Dendo Kyokai)

Zen is not some kind of excitement, but concentration
on our usual everyday routine.

—SHUNRYU SUZUKI

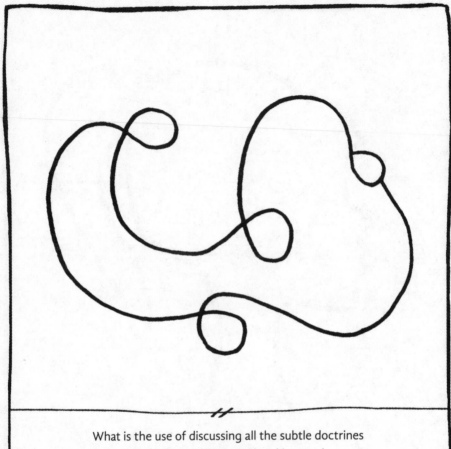

What is the use of discussing all the subtle doctrines
about the soul? Do good and be good.

—BUDDHA

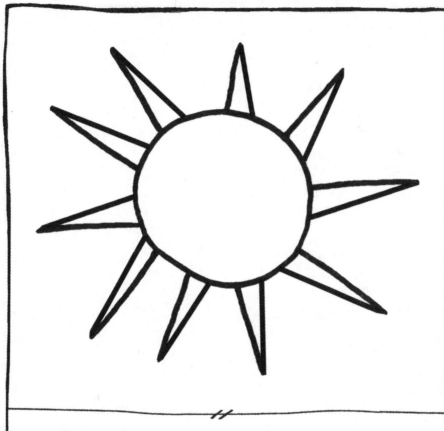

The stream of your meditation flows on gently and steadily like a mighty river. Finally all your thoughts, both coarse and subtle, set (like the sun) and you settle in equipoise into a non-conceptual state.

—KARMAPA IX (Wangchuk Dorje)

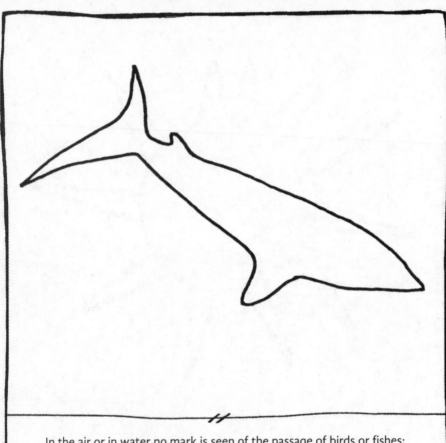

In the air or in water no mark is seen of the passage of birds or fishes;
so is entirely inscrutable the passage of the knowers of the Self.

—HINDU PROVERB

In the garden of my heart the flowers of peace bloom beautifully.

—THICH NHAT HANH

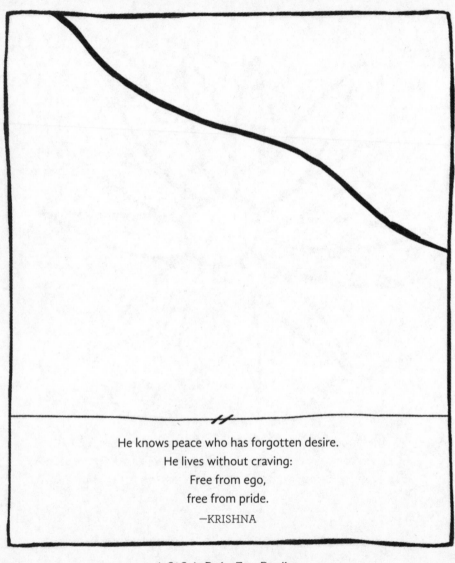

He knows peace who has forgotten desire.
He lives without craving:
Free from ego,
free from pride.

—KRISHNA

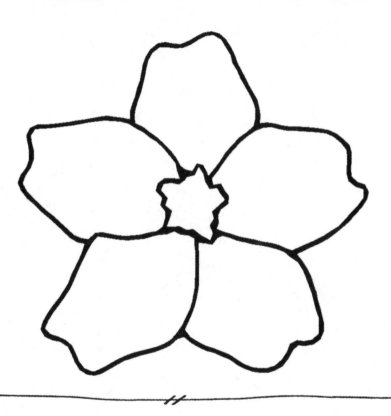

Words may be beautiful, but like the unscented flower, they do not necessarily carry sincerity, whereas the scented flower delivers what its beauty decrees. Your words should carry conviction in the same way.

—BUDDHA

We are not separate from this universe.
Our bodies are simply little whirlpools in the ocean of matter.
The sun, the moon, the stars, you and I; all mere whirlpools.
—SWAMI VIVEKANANDA

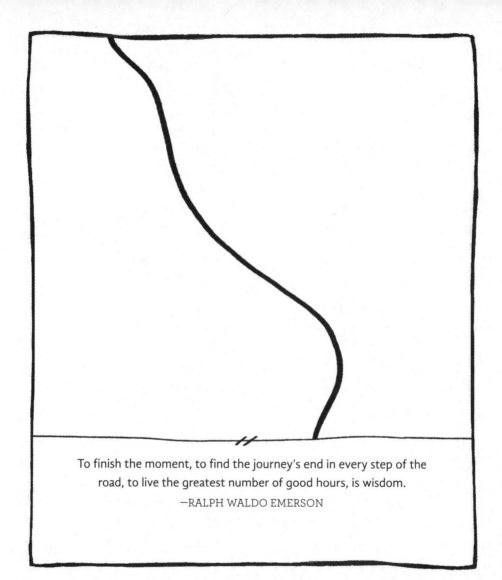

To finish the moment, to find the journey's end in every step of the road, to live the greatest number of good hours, is wisdom.

—RALPH WALDO EMERSON

To adhere to a thing because of its form is the source of delusion.
If the form is not grasped and adhered to, this false imagination
and absurd delusion will not occur. Enlightenment is seeing
this truth and being free from such a foolish delusion.

—BUDDHA (as quoted by Bukkyo Dendo Kyokai)

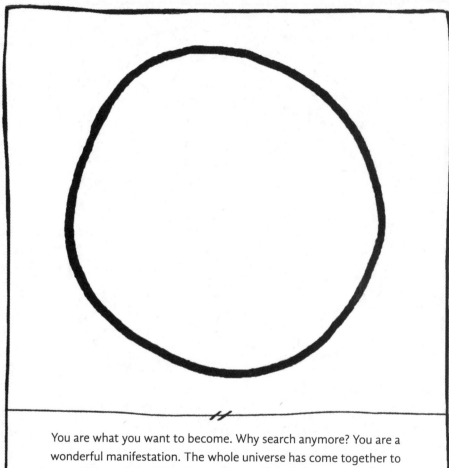

You are what you want to become. Why search anymore? You are a wonderful manifestation. The whole universe has come together to make your existence possible. There is nothing that is not you.

—THICH NHAT HANH

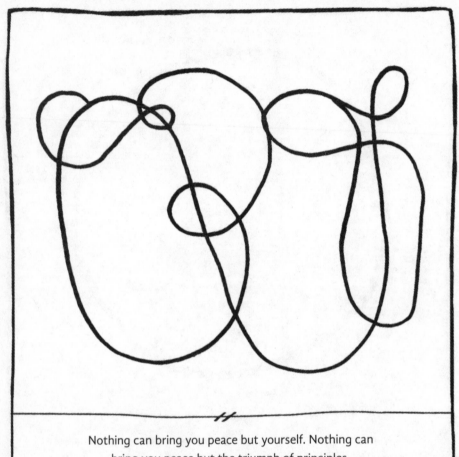

Nothing can bring you peace but yourself. Nothing can
bring you peace but the triumph of principles.

—RALPH WALDO EMERSON

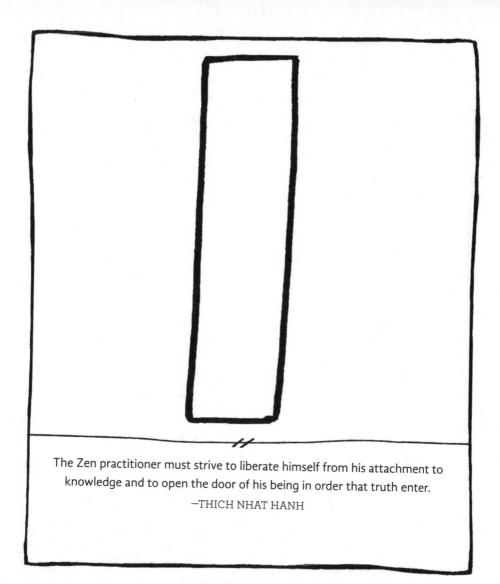

The Zen practitioner must strive to liberate himself from his attachment to knowledge and to open the door of his being in order that truth enter.

—THICH NHAT HANH

When you begin to see that your enemy is suffering,
that is the beginning of insight.

—THICH NHAT HANH

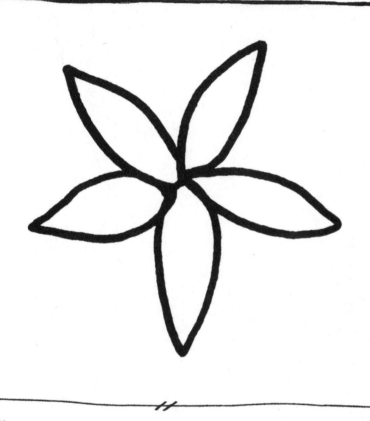

Thou art one with this Universal Being, and, as such, every soul that exists is your soul; and every body that exists is your body; and in hurting anyone, you hurt yourself, in loving anyone, you love yourself.

—SWAMI VIVEKANANDA

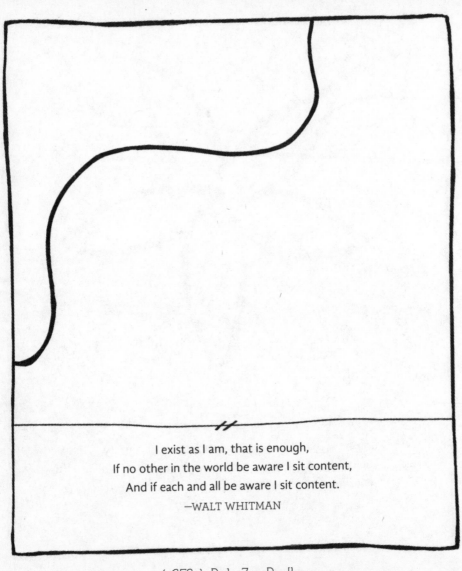

I exist as I am, that is enough,
If no other in the world be aware I sit content,
And if each and all be aware I sit content.

—WALT WHITMAN

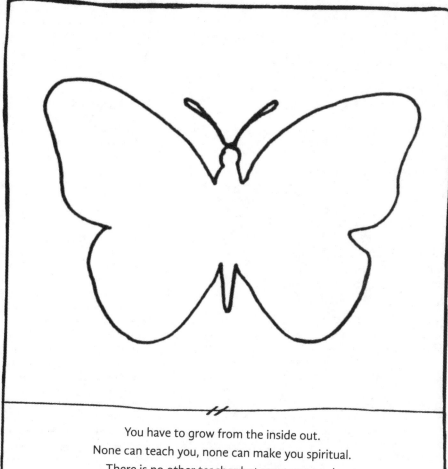

You have to grow from the inside out.
None can teach you, none can make you spiritual.
There is no other teacher but your own soul.

—SWAMI VIVEKANANDA

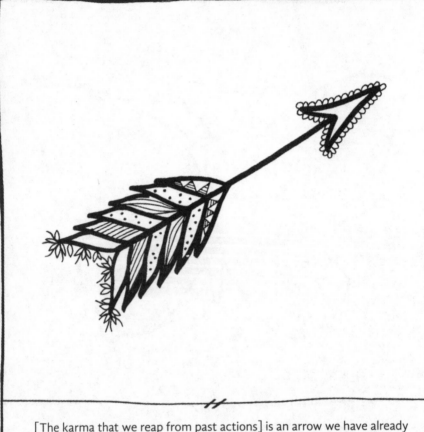

[The karma that we reap from past actions] is an arrow we have already
shot: it is on its way, and the best we can do is accept the suffering that
comes from it and learn from that suffering not to shoot that arrow again.

—EKNATH EASWARAN

The happiest man is the man who has destroyed all of his selfishness.

—SWAMI VIVEKANANDA

If you realize that all things change, there is nothing you will try to hold on to. If you aren't afraid of dying, there is nothing you can't achieve. Trying to control the future is like trying to take the master carpenter's place. When you handle the master carpenter's tools, chances are that you'll cut your hand.

—LAO TZU

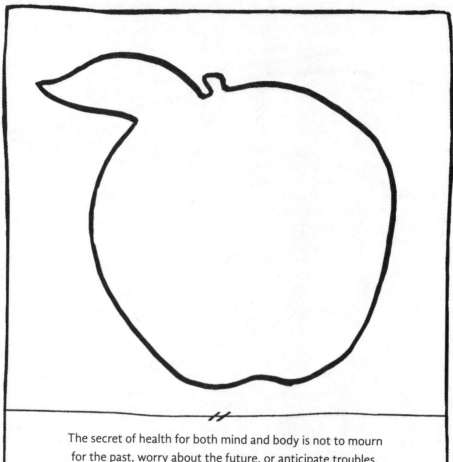

The secret of health for both mind and body is not to mourn
for the past, worry about the future, or anticipate troubles,
but to live in the present moment wisely and earnestly.

—PARAMAHANSA YOGANANDA

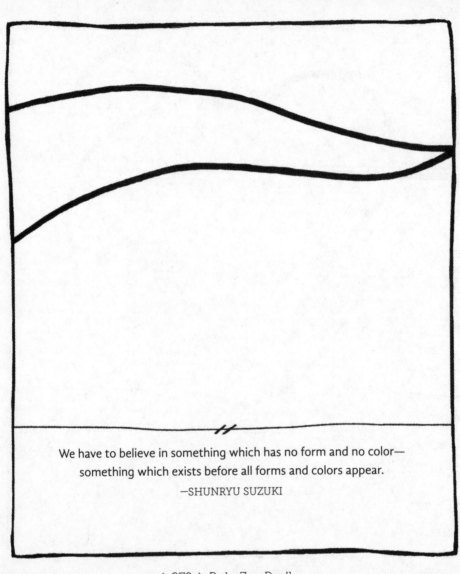

We have to believe in something which has no form and no color—
something which exists before all forms and colors appear.

—SHUNRYU SUZUKI

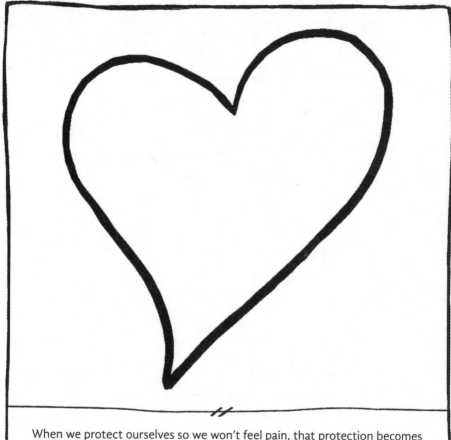

When we protect ourselves so we won't feel pain, that protection becomes like armor, like armor that imprisons the softness of the heart.

—PEMA CHÖDRÖN

In proportion as [one] simplifies his life, the laws of the universe will appear less complex, and solitude will not be solitude, nor poverty poverty, nor weakness weakness. If you have built castles in the air, your work need not be lost; that is where they should be. Now put the foundations under them.

—HENRY DAVID THOREAU

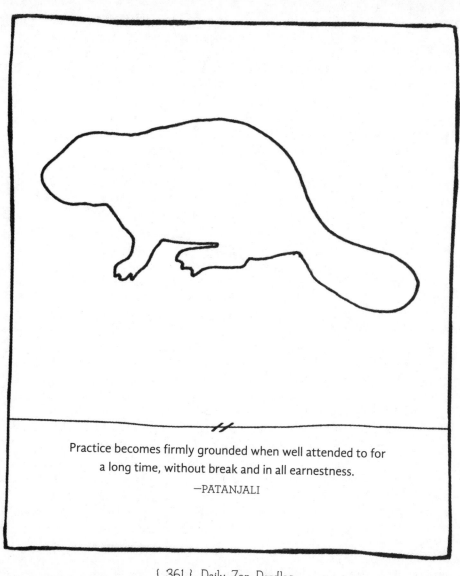

Practice becomes firmly grounded when well attended to for
a long time, without break and in all earnestness.

—PATANJALI

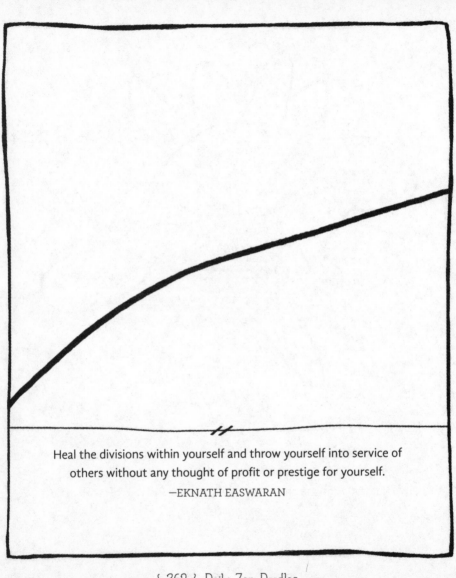

Heal the divisions within yourself and throw yourself into service of others without any thought of profit or prestige for yourself.

—EKNATH EASWARAN

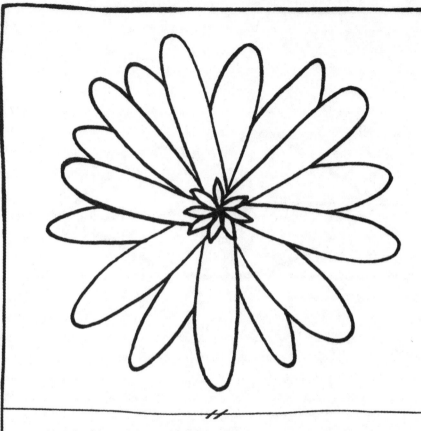

Here in this emptiness there is no form, no perception, no name, no concepts, no knowledge. No eye, no ear, no nose, no tongue, no body, no mind. No form, no sound, no smell, no taste, no touch, no objects.

—D.T. SUZUKI

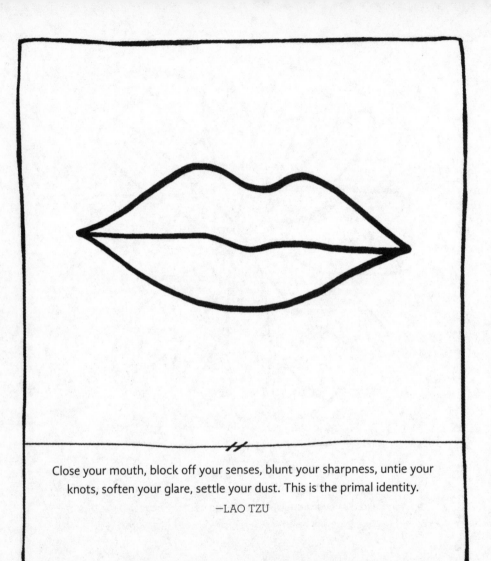

Close your mouth, block off your senses, blunt your sharpness, untie your knots, soften your glare, settle your dust. This is the primal identity.

—LAO TZU

There is...in the essence of everything, something that we cannot call learning. There is...only a knowledge—that is everywhere, that is Atman, that is in me and you and in every creature, and I am beginning to believe that this knowledge has no worse enemy than the man of knowledge, than learning.

—HERMANN HESSE

All over the world, everybody always strikes out at the enemy, and the pain escalates forever. Every day we could...ask ourselves, "Am I going to add to the aggression in the world?" Every day, at the moment when things get edgy, we can just ask ourselves, "Am I going to practice peace, or am I going to war?"

—PEMA CHÖDRÖN

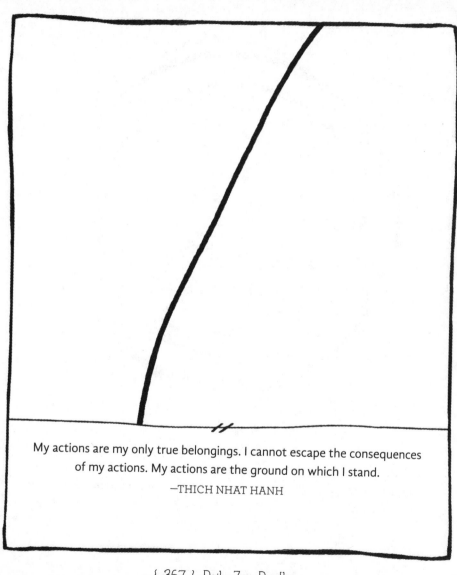

My actions are my only true belongings. I cannot escape the consequences of my actions. My actions are the ground on which I stand.

—THICH NHAT HANH

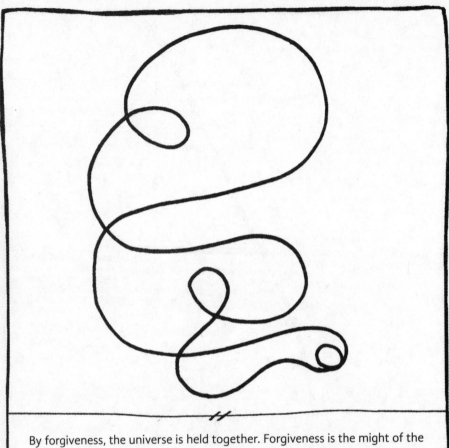

By forgiveness, the universe is held together. Forgiveness is the might of the mighty; forgiveness is sacrifice; forgiveness is quiet of mind. Forgiveness and gentleness are the qualities of the Self-possessed. They represent eternal virtue.

—SRI DAYA MATA

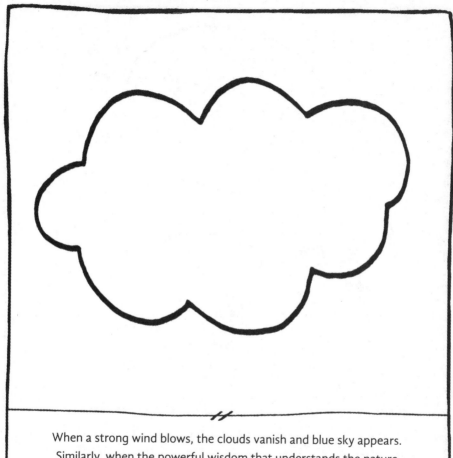

When a strong wind blows, the clouds vanish and blue sky appears. Similarly, when the powerful wisdom that understands the nature of the mind arises, the dark clouds of ego disappear.

—LAMA YESHE

The reason why the world lacks unity, and lies broken and in heaps, is because man is disunited with himself. He cannot be a naturalist until he satisfies all the demands of the spirit.

—RALPH WALDO EMERSON

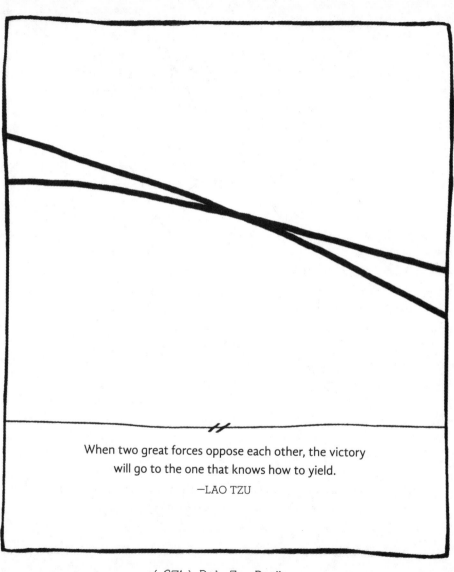

When two great forces oppose each other, the victory
will go to the one that knows how to yield.

—LAO TZU

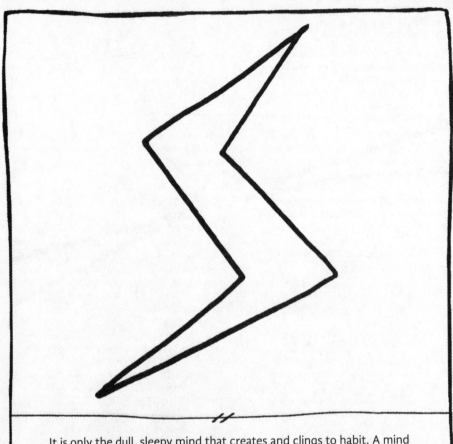

It is only the dull, sleepy mind that creates and clings to habit. A mind that is attentive from moment to moment—attentive to what it is saying, attentive to the movement of its hands, of its thoughts, of its feelings— will discover that the formation of further habits has come to an end.

—KRISHNAMURTI

Bibliography

The *Bhagavad Gita*. Swami Prabhavananda and Christopher Isherwood, translators. New York: Barnes and Noble, 1995.

Bodhidharma. *The Zen Teaching of Bodhidharma*. New York: North Point Press, 1987.

Chödrön, Pema. *No Time to Lose: A Timely Guide to the Way of the Bodhisattva*. Boston: Shambala, 2005.

Chödrön, Pema. *Start Where You Are: A Guide to Compassionate Living*. Boston: Shambala, 2001.

Chödrön, Pema. *When Things Fall Apart: Heart Advice for Difficult Times*. Boston: Shambala, 2002.

Chopra, Deepak. *The Seven Spiritual Laws of Success: A Practical Guide to the Fulfillment of Your Dreams*. San Rafael, California: Amber-Allen Publishing, 1994.

Crosweller, David. *Reflections of Buddha for Every Day*. Boston: Journey Editions, 1999.

The Dalai Lama. *Beyond Religion: Ethics for a Whole World*. New York: Mariner Books, 2012.

The Dalai Lama. *Ethics For the New Millennium*. New York: Riverhead Books, 2001.

The Dalai Lama. *From Here to Enlightenment: An Introduction to Tsong-kha-pa's Classic Text The Great Treatise on the Stages of the Path to Enlightenment*. Guy Newland, editor and translator. Boston: Shambala, 2012.

Daya Mata, Sri. *Enter the Quiet Heart: Creating a Loving Relationship with God*. Los Angeles: Self-Realization Fellowship, 1998.

The Dhammapada. Valerie Roebuck, editor and translator. New York: Penguin Classics, 2010.

Dogen, Eihei. *Beyond Thinking: A Guide to Zen Meditation*. Boston: Shambala, 2004.

Easwaran, Eknath. *Passage Meditation: Bringing the Deep Wisdom of the Heart into Daily Life*. Tomales, California: Nilgiri Press, 2008.

Easwaran, Eknath. *The End of Sorrow: The Bhagavad Gita for Daily Living, Volume I*. Tomales, California: Nilgiri Press, 1993.

Easwaran, Eknath. *Like a Thousand Suns: The Bhagavad Gita for Daily Living, Volume II*. Tomales, California: Nilgiri Press, 1993.

Emerson, Ralph Waldo. *The Essential Writings of Ralph Waldo Emerson*. New York: Random House, 2009.

Emerson, Ralph Waldo. *Nature and Selected Essays*. New York: Penguin Classics, 2003.

Emerson, Ralph Waldo. *The Works of Ralph Waldo Emerson, Volume 3*. London: George Belle and Sons, 1904.

Eves, Howard W. *Mathematical Circles Adieu and Return to Mathematical Circles*. Washington, DC: The Mathematical Association of America, 2003.

Gandhi, Mohandas Karamchand. *Autobiography: The Story of My Experiments with Truth*. Boston: Beacon Press, 1993.

Giten, Swami Dhyan. *Presence: Working from Within, The Psychology of Being*. 2013. [Available online via Lulu Marketplace: http://www.lulu.com/us/en/shop/swami-dhyan-giten/presence-working-from-within-the-psychology-of-being/paperback/product-21156468.html]

Giten, Swami Dhyen. *The Silent Whisperings of the Heart: An Introduction to Giten's Approach*. 2012. [Available online via Lulu Marketplace: http://www.free-ebooks.net/ebook/The-Silent-Whisperings-of-the-Heart-An-Introduction-to-Giten-s-Approach-to-Life]

Hesse, Hermann. *Siddhartha*. Hilda Rosner, translator. New York: Bantam, 1971.

Johnston, Charles. *The Yoga Sutras of Patanjali—"The Book of the Spiritual Man"—An Interpretation by Charles Johnston*. New York: Charles Johnston, 1912.

Kabat-Zinn, Jon. *Wherever You Go, There You Are: Mindfulness Meditation in Everyday Life*. New York: Hyperion, 1995.

Karmapa IX (Wangchuk Dorje). *The Mahamudra: Eliminating the Darkness of Ignorance*. Dharmasala, India: LTWA (Library of Tibetan Works and Archive), 1989.

Keith, Kent M. *The Silent Revolution: Dynamic Leadership in the Student Council*. Honolulu: Terrace Press, 2003.

Khyentse, Dilgo. *The Heart of Compassion: The Thirty-Seven Verses on the Practice of a Bodhisattva*. Boston: Shambala, 2007.

Khyentse, Dilgo, commentator. *The Heart Treasure of the Enlightened Ones: The Practice of View, Meditation, and Action: A Discourse Virtuous in the Beginning, Middle, and End*. Boston: Shambala, 1992.

Khyentse, Dilgo and Padampa Sangye. *The Hundred Verses of Advice: Tibetan Buddhist Teachings on What Matters Most*. Boston: Shambala, 2006.

Khyentse, Dzongsar Jamyang. *What Makes You Not a Buddhist*. Boston: Shambala, 2008.

Krishnamurti, Jiddu. *The Book of Life: Daily Meditations with Krishnamurti*. San Francisco: HarperSanFrancisco, 1995.

Lao Tzu. *Tao Te Ching: A New English Version*. Stephen Mitchell, translator. New York: HarperCollins, 1988.

Lokos, Allan. *Patience: The Art of Peaceful Living*. New York: Tarcher/Penguin Group, 2012.

Lokos, Allan. *Pocket Peace: Effective Practices for Enlightened Living*. New York: Tarcher/Penguin Group, 2010.

Nhat Hanh, Thich. *Going Home: Jesus and Buddha as Brothers*. New York: Riverhead Books, 2000.

Nhat Hanh, Thich. *Living Buddha, Living Christ*. New York: Riverhead Books, 2007.

Nhat Hanh, Thich. *The Miracle of Mindfulness: An Introduction to the Practice of Meditation*. Boston: Beacon Press, 1996.

Nhat Hanh, Thich. *No Death, No Fear: Comforting Wisdom for Life*. New York: Riverhead Books, 2002.

Nhat Hanh, Thich. *Peace Is Every Breath: A Practice for Our Busy Lives*. New York: HarperCollins Publishers, 2011.

Nhat Hanh, Thich. *Peace Is Every Step: The Path of Mindfulness in Everyday Life*. New York: Bantam Books, 1991.

Nhat Hanh, Thich. *Stepping into Freedom: An Introduction to Buddhist Monastic Training*. Berkeley: Parallax Press, 1997.

Nhat Hanh, Thich. *Touching Peace: Practicing the Art of Mindful Living*. Berkeley: Parallax Press, 2013.

Nhat Hanh, Thich. *Understanding Our Mind: 50 Verses on Buddhist Psychology*. Berkeley: Parallax Press, 2006.

Nisargadatt Maharaj, Sri. *I Am That*. Durham, North Carolina: Acorn Press, 2012.

Patanjali, et al. *300 Quotes From Hinduism: From More Than Forty Sources*. [n.p.]: Freedom Religion Press, 2013.

Powerful Buddhist Quotes. [n.p.]: Jikaku Publications, 2013.

Ramacharaka, Yogi. *The Spirit of the Upanishado, Or The Aphorisms of the Wise*. New York: Cosimo, Inc., 2007.

Ramana, Maharshi. *The Collected Works of Sri Ramana Maharshi*. Arthur Osborne, editor and translator. India: Sri Ramanasramam/Tiruvannamalai, 2014.

Richards, Stephen. *The Ultimate Cosmic Ordering Meditation* [audiobook]. Mirage Publishing, 2009.

The Rig Veda. Wendy Doniger, translator and annotator. London: Penguin, 1981.

Sankara, Adi. *Powerful Quotes from Sankara*. [n.p.]: Freedom Religion Press, 2012.

Satchidananda, Swami. *The Yoga Sutras of Patanjali*. Yogaville, Virginia: Integral Yoga Publications, 1990.

Schrödinger, Erwin. *My View of the World*. Cecily Hastings, translator. Woodbridge, Connecticut: Ox Bow Press, 1983.

Smith, Betty. *A Tree Grows in Brooklyn*. New York: Harper Perennial Modern Classics, 2006.

Sogyal, Rinpoche. *The Tibetan Book of Living and Dying*. Revised and updated edition. New York: HarperSanFrancisco, 2002.

Suzuki, D. T. *An Introduction to Zen Buddhism*. New York: Grove Press, 1994.

Suzuki, Shunryu. *Zen Mind, Beginner's Mind*. Boston: Shambala, 2006.

Tagore, Rabindranath. *Gitanjali (Song Offering)*. New York: Macmillan, 1952.

Tagore, Rabindranath. *I Won't Let You Go: Selected Poems*. Ketaki Kushari Dyson, translator. London: Penguin Books, 2010.

The Teaching of Buddha. Bukkyo Dendo Kyokai (Society for the Promotion of Buddhism). Tokyo: Kosaido Printing, 1997.

Thoreau, Henry David. *Essays: A Fully Annotated Edition*. New Haven: Yale University, 2013.

Thoreau, Henry David. *Walden; Or, Life in the Woods*. Mineola, New York: Dover Publications, 1995.

Tolstoy, Leo Nikolayevich. *Essays, Letters, and Miscellanies*. Rockville, Maryland: Wildside Press, 2010.

Trungpa, Chögyam. *The Bodhisattva Path of Wisdom and Compassion: The Profound Treasury of the Ocean of Dharma, Volume II*. Judith Lief, compiler and editor. Boston: Shambala, 2013.

Trungpa, Chögyam. *The Collected Works of Chögyam Trungpa, Volume VIII*. Boston: Shambala, 2004.

Trungpa, Chögyam. *Shambala: Sacred Path of the Warrior*. Boston: Shambala, 2007.

Trungpa, Chögyam. *True Perception: The Path of Dharma Art*. Boston: Shambala, 2008.

Trungpa, Chögyam. *Work, Sex, Money: Real Life on the Path of Mindfulness*. Boston: Shambala, 2011.

Uchiyama, Kosho. *Approach to Zen*. Tokyo: Japan Publications, 1973.

The Upanishads, Volume 1. F. Max Müller, translator. Whitefish, Montana: Kessinger Publishing, 2004.

The Upanishads. Angirasa Muni, translator. Fort Wayne: Sacred Books, 1999.

The Vedas. Angirasa Muni, translator. Fort Wayne: Sacred Books, 1999.

Vivekananda, Swami. *The Complete Works of Swami Vivekananda*. Calcutta, India: Advaita Ashrama, 1989.

Vivekananda, Swami. *Pathways to Joy: The Master Vivekananda on the Four Yoga Paths to God*. Makawao, Hawaii: Inner Ocean Publishing, 2006.

Vivekananda, Swami. *Pearls of Wisdom*. Calcutta, India: Ramakrishna Mission, Institute of Culture, 1988.

Vivekananda, Swami. *Vivekananda: His Call to the Nation*. Calcutta, India: Advaita Ashrama, 2014.

Wallace, David Foster. *Infinite Jest*. Bay Back Books, 2006.

Wallace, David Foster. *This Is Water: Some Thoughts, Delivered on a Significant Occasion, about Living a Compassionate Life*. New York: Little, Brown, 2009.

Watts, Alan W. *The Book: On the Taboo Against Knowing Who You Are*. New York: Vintage Books, 1989.

Watts, Alan W. *Psychotherapy East and West*. New York: Ballantine, 1961.

Watts, Alan W. *Wisdom of Insecurity: A Message for an Age of Anxiety*. New York: Vintage, 2011.

Whitman, Walt. *Leaves of Grass. 1855 First Edition Text*. Radford, Virginia: Wilder Publications, 2008.

Wolter, Doris, editor. *Losing the Clouds, Gaining the Sky: Buddhism and the Natural Mind*. Somerville, Massachusetts: Wisdom Publications, Inc., 2007.

Yeshe, Lama. *Becoming Your Own Therapist: An Introduction to the Buddhist Way of Thought*. Boston: Lama Yeshe Wisdom Archive, 1998.

Yogananda, Paramahansa. *Autobiography of a Yogi*. Los Angeles: Self-Realization Fellowship, 1998.

Yogananda, Paramahansa. *The Science of Religion*. Los Angeles: Self-Realization Fellowship, 1982.

Acknowledgments

I am grateful to everyone who has helped me along my path (knowingly or otherwise).

My heart goes to: OPD, SD, and KP, whose unfailing encouragement and support keep me reaching for more; AS and AB, whose spirits are intertwined with mine; KB, who has taught me my greatest lessons; JR, for her excitement at every new turn; BH, whose kindness has irrevocably shaped me; TT and LC, whose friendships continue to sparkle and surprise me in their sincerity; and Ari Emerson, whose smile carries me over every troubled water.

About the Author

MEERA LEE PATEL is an author and illustrator raised by the New Jersey shore, where she swam the bright waters and climbed cherry blossom trees until she grew old enough to draw them. Her work is inspired by the magical mysteries of nature, the quiet stories that lace through everyday life, and the bold colors of her native India. Happiest when sleeping or smiling, she lives and works in Brooklyn, New York. Visit her online at www.meeralee.com.